TEAPOTS
TRANSFORMED

Exploration of an Object

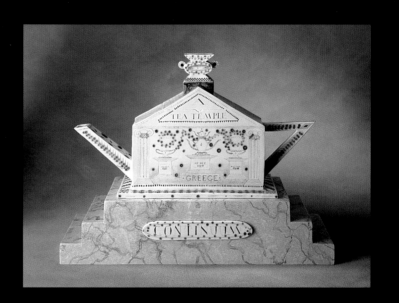

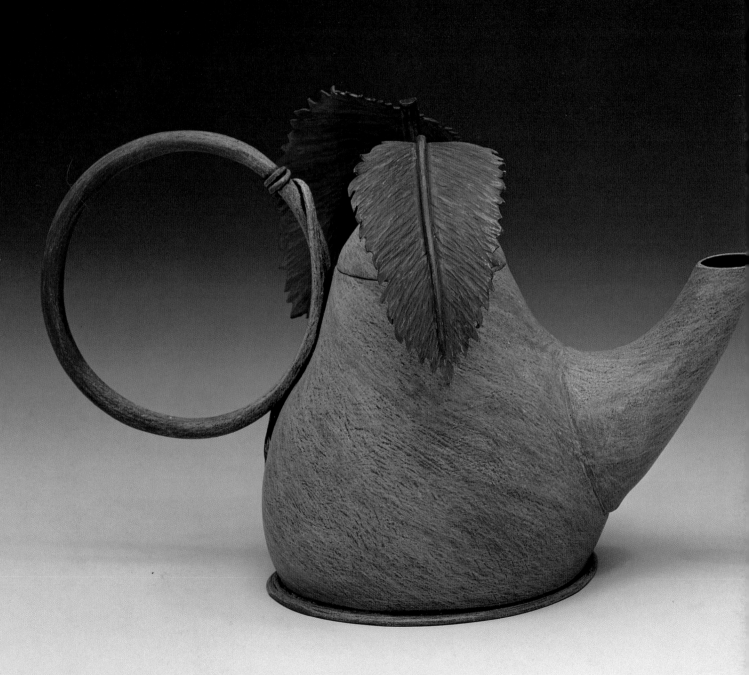

LESLIE FERRIN

TEAPOTS
TRANSFORMED
Exploration of an Object

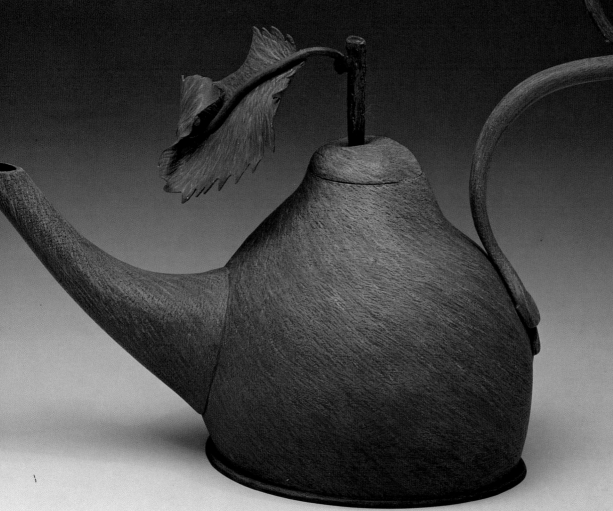

GUILD Publishing, Madison, Wisconsin
Distributed by North Light Books, Cincinnati, Ohio

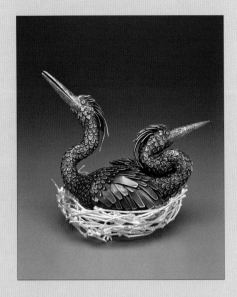

Teapots Transformed: Exploration of an Object

Leslie Ferrin

Copyright © 2000 by GUILD Publishing
Text copyright © 2000 by Leslie Ferrin

Chief editorial officer: Katie Kazan
Design and production: Ann Schaffer
Editor: Dawn Barker
Assistant editor: Nikki Muenchow

00 01 02 03 04 05 06 7 6 5 4 3 2 1

Published by
GUILD Publishing, an imprint of GUILD.com
931 East Main Street
Madison, WI 53703 USA
TEL 608-257-2590 • TEL 877-284-8453 • FAX 608-227-4179

Distributed to the trade and art markets in North America by North Light Books, an imprint of F&W Publications, Inc.
1507 Dana Avenue
Cincinnati, OH 45207
TEL 800-289-0963

Printed in China

ISBN 1-893164-08-X

Front cover artwork:
Michael Sherrill, *Halcyon Tea*, thrown, altered and extruded stoneware with 23K gold leaf, 14"H x 21½"W x 6"D, collection of Sonny and Gloria Kamm, photo by Tim Barnwell.

Page 1 artwork:
Mara Superior, *A Tea Temple*, porcelain with painted wood base, 1998, 15"H x 20"W x 10"D, collection of artist, photo by Susie Cushner; courtesy of Ferrin Gallery.

Pages 2–3 artwork:
Marilyn da Silva, *An Unlikely Pair*, copper, gesso and colored pencil, 1999, each 3½"H x 4"W x 2½"D, collection of Daphne Farago, photo by Philip Cohen; courtesy of Mobilia Gallery.

This page:
Robin Kraft, *Throat Soothers*, sterling silver, 1999, 8"H x 8"W x 8"D, collection of Celestial Seasonings.

GUILD Publishing is an imprint of GUILD.com, which represents artists 24 hours a day at www.guild.com, including some of the artists featured in this book.

TABLE OF CONTENTS

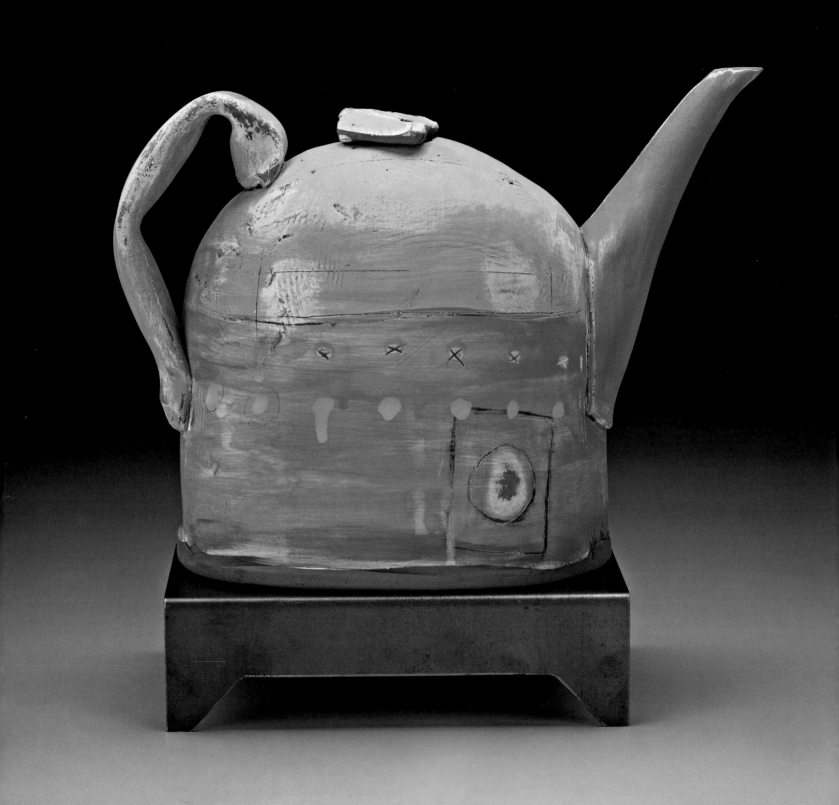

INTRODUCTION

P inch Pottery held its first teapot show in 1979, when I was a producing potter. The teapot, with its intrinsic charm and challenges, seemed a good way of bringing together the varied works of many artists. The enthusiastic response from both the participating artists and visitors set me on a new path: organizing annual teapot shows that attracted growing attention from the public, the press and — even more important — collectors. Gradually I became caught up in the search for new work to satisfy the collector community, left the studio behind, and opened Ferrin Gallery. This book is an inevitable next step — an enthusiastic dealer's effort to expand the world of teapot makers, admirers and collectors.

The Garth Clark Gallery, which opened in 1981, held its first show of teapots, "Rituals of Tea," in 1983. That exhibition was followed by regular shows in both their New York and Los Angeles locations throughout the 1980s and 1990s. The gallery was one of very few to focus primarily on ceramics in the vessel tradition, and throughout this period they represented many of the important artists who were active in the teapot genre. Craft Alliance in St. Louis and Dorothy Weiss Gallery in San Francisco were among many other galleries that held regular teapot shows throughout the 1980s and 1990s. Hundreds of artists have passed through the roster of these survey shows, which have served to chronicle the growth, development and changes taking place in the wider field of ceramics. As artists working in all media began to explore the form, the teapot became established as an important genre within the craft movement and among artists in general.

The text in this book will reveal only some of the many artists, collectors and authorities in the field who have enriched this work with their conversations, observations and loans. I am grateful to them all for making my quest such a pleasure. My research in the realm of ceramic literature was equally pleasurable, and I am happy to share that experience. A recommended reading list following the last chapter includes several in-depth ceramic histories and books on the teapot and on individual artists who have been influential within the genre. I hope readers of this book will be inspired to reach for these texts and learn more about the artists, the history of teapots and how they have come together in the last half of the 20th century.

Leslie Ferrin

Nancy Selvin, *Teapot*, terra-cotta with underglaze, 1998, 10"H x 8"W x 4"D.

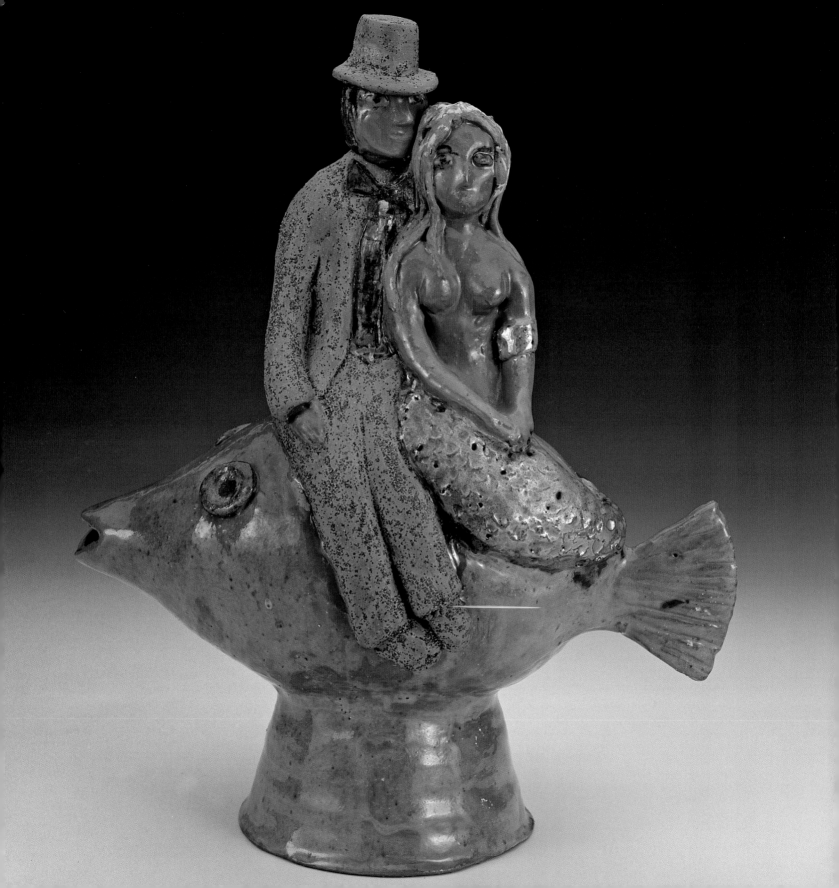

THE APPEAL OF THE TEAPOT

I n the past 30 years, the contemporary American teapot has become the most significant object of decorative and applied art being produced and collected. Thousands of artists, working in all media, have embraced the teapot, creating individual testimonials to this appealing form. They have been encouraged by the patronage of numerous collectors, whose holdings represent the very finest pieces.

The appeal of the teapot is many faceted. Throughout its 400-year history, the teapot has had a rich biography, its chapters filled with cultural and social meaning. From the tea trade with China (and later India) to the politicization of tea in colonial America, through later events such as the 1848 tea party that led to the first women's rights convention, tea has played a dramatic role both socially and economically.

For collectors, acquiring artwork thematically offers the opportunity to own and display pieces by diverse artists while keeping their interest focused and collections unified. A theme gives the collector certain boundaries to manage an enthusiastic pursuit and a clear direction for his or her passion. Within these constraints, the choices are limitless.

For both the artist and the collector, the teapot's anthropomorphic form suggests human characteristics — head, arms and body. The image of the teapot conveys a sense of warmth and evokes a feeling of home. In countless illustrations, commercial advertising and greeting cards, the teapot is used as a symbol. Whether sitting on a table surrounded by scones or steaming on the hearth, the teapot has become an icon representing appealing values.

Beatrice Wood, *Mermaid Teapot*, earthenware with luster glazes, 1991, 14"H x 11½"W x 6"D, The Donna Moog Teapot Collection, Charles A. Wustum Museum of Fine Arts, Racine, WI. "Beatrice Wood's *Mermaid Teapot* is not a classic representation of a siren enticing a sailor to his death on the rocks. Instead, with a playful sense of humor, Wood pairs this mermaid with a formally attired gentleman, as if he were her groom. Instead of an icon of mythology, Wood creates a pair who behave casually as tourists on their honeymoon. This siren has caught her sailor . . . and married him," according to Bruce W. Pepich, Director, Charles A. Wustum Museum of Fine Arts.

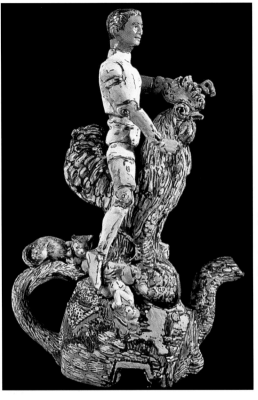

Photo by M. Lee Fatherree; courtesy of Rena Bransten Gallery

Viola Frey, *Manikin and Rooster Teapot,* ceramic, 1975, 14"H x 12"W x 10"D, collection of artist.

Today the teapot has one foot in the kitchen and the other in the art world. Some teapot artists' work falls clearly into one realm or the other, but much of the excitement for both the producer and the collector are in those pieces that challenge the division between the two.

THE TECHNICAL CHALLENGE

Contemporary artists draw inspiration from the social and cultural history of the teapot, but it is the technical challenge of making the parts work together within a personal expressive statement that attracts them in such great numbers. The functional teapot needs to balance well in the hand, sit firmly on its base, pour without dripping and have a lid that fits snugly and does not fall out when tipped for pouring. Ceramic artists, for example, must use their materials skillfully so that the various parts of the teapot — handle, spout, lid, body, foot and surface — hold together without cracking during the drying and firing processes.

Expert craftsmanship is necessary to execute either functional or sculptural ideas, but even more challenging is integration of content, surface and form within the technical limitations. In the end, it is the search for a balance between craftsmanship and artistic content that has produced the remarkable body of work of thousands of artists over the past 30 years.

MULTICULTURAL INFLUENCES

In Europe, the design of teapots began in the 17th century with the tea trade with China. Both the tea itself and the porcelain containing it became highly valued in the West. As demand increased, the trade brought with it amusing cross-cultural expressions; Western images were depicted on the Chinese porcelain produced for the Western market. Later the reverse occurred, as Asian images such as the Blue Willow pattern were used on European ceramics.

Chinese Yixing ware was a major source of design influence in Europe, and it remains influential throughout the Western world. Yixing ceramics were unglazed and small scale. They often depicted natural forms — leaves, fruit, bamboo and animals — and were prized for their individuality. The first Yixing teapots arrived in England from China during the 1600s packed in with the shipments of tea. The earliest surviving intact teapot bears the name Gong Chun, a well-known teapot maker during the Ming dynasty. Artistic individuality continued to be valued during the 1700s, when potters collaborated with poets, who inscribed poems into the surfaces of the pots. In the 1700s, as items of foreign trade, Yixing ware became influential, providing inspiration to potters such as Josiah Wedgewood.

Photo by Richard Marquis, courtesy of Elliott Brown Gallery

Richard Marquis, *Ceramic Coffeepots and Tea Kettle,* colored low-fire clay with clear glazes, 1971–1972, tallest: 9¼"H, collection of artist.

Photo by Kohler Art Center

Coille McLaughlin Hooven, *Cabbage Road,* Kohler vitreous china, 1979, 8"H x 19"W x 9"D, collection of artist. Coille McLaughlin Hooven says, "I liken my work to dream interpretation. It is both literal and symbolic, intended to evoke a feeling that lingers. I don't work from a preconceived idea or sketch. I work directly from my unconscious, and I'm often surprised by what emerges. I use my work as a window to my inner self. The teapot form offers more room for individual expression than any other — [its] appositional spout, handle, lid, surface and content are an irresistible challenge and endless source of ideas."

Chinese wine vessels were another design source — larger than the Yixing teapots and taller. Islamic coffeepots also served as a source of design ideas — at a time when coffee- and teapots shared the same form. Small-scale pots were made first, as tea was too valuable to use in a larger vessel. Large-scale teapot forms were produced, but they were used for "punch," an alcoholic grog. Later, as tea became more widely grown and imported, the familiar middle-sized teapot became the norm. While the highly aesthetic Japanese tea ceremony is a major influence on contemporary potters both for its philosophy and its revered forms, Japanese tea was primarily brewed and served in tea bowls, not teapots, and was not a major influence on Western teapot design.

AMERICA, THE MELTING POT

The teapot in America can be examined from its "melting pot" origins. Starting in the 1700s with the Boston Tea Party, both tea and the objects related to tea service have been surrounded by cultural, economic, political and social issues. As a colony of England, America inherited a cross-cultural concept of tea that combined Eastern and Western influences. The teapots used in 18th-century America were generally imported from England or, for the very well off, from China. They demonstrated refinement, taste and status. According to Amanda Lange, Associate Curator of Historic Deerfield in Massachusetts, "Locally made redware did not convey sufficient wealth and status to be used on the tea table. Anyone with the means to afford tea desired the appropriate ceramics, which were made of finer clays and were thinner, lighter and whiter than American redwares. Chinese export porcelains and English earthenwares and stonewares were most popular."

Three hundred years later, these cross-cultural traditions continue to exert influence on American artists. The "melting pot" has grown, as contemporary artists freely draw inspiration and source ideas from the vast history of decorative art, fine art and commercial art. Styles, techniques, forms and concepts from throughout history become reference material or direct subjects for their work.

AMERICAN STUDIO POTTERY

The contemporary movement of artists producing objects of their own design in their own studios from start to finish dates from the mid-1850s. Until then, most ceramic work was produced in a factory or guild setting, and design was dictated by tradition. In Europe, Asia had been a major influence on teapot design through the tea trade. In America, for different reasons, Asian aesthetics and techniques played an equally important role.

The model for the studio potter as we know it today can be traced to a studio in England established by Bernard Leach in 1920. Leach, who trained in Japan, set up a studio at St. Ives in Cornwall, England, and, along with Japanese potter Shoji Hamada, made Japanese-style stoneware and English-style slipware. Their use of indigenous materials and their self-supporting studio with an apprenticeship and teaching program producing functional pottery for daily use has become

known as the "Leach tradition." Many contemporary studio potters continue to draw direct inspiration from Leach and Hamada's Asian and British forms, their writings, their techniques and their economic self-sufficiency.

In America in the 1950s, two of Leach and Hamada's student apprentices, Warren and Alix MacKenzie, established a pottery in Stillwater, Minnesota, based on the Leach model. Warren MacKenzie became influential through teaching at the University of Minnesota. The number of Midwestern potters following in the Leach tradition eventually gave rise to the label "Mingeisota." First used as a pejorative, this is now a somewhat affectionate term combining the word for Japanese folk art, *Mingei*, with *Minnesota*. Teapots produced in this tradition are characterized by simplicity of form and decoration and a deep respect for materials and process. They are often produced by potters committed to an equally simple lifestyle sustained by producing affordable pottery for day-to-day use.

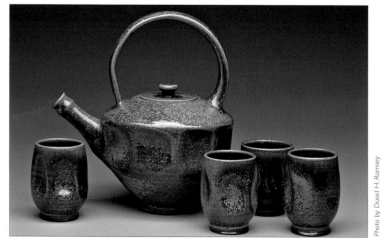

Ben Owen III, *Faceted Teapot with Cups*, wood-fired stoneware with Oribe copper glaze, 2000, teapot: 11½"H x 9½"W x 6½"D, cups: 4"H x 3"D, collection of Fran and Wayne Irvin. Ben Owen III comes from a long line of potters in the Seagrove area of North Carolina. His grandfather, Ben Owen, learned his craft from his father and was later hired by Jugtown Pottery. There he expanded the traditional design vocabulary by incorporating decoration, forms and glazes inspired by Asian ceramics. Ben Owen III continues in the spirit of his family, drawing inspiration from both folk pottery and international influences.

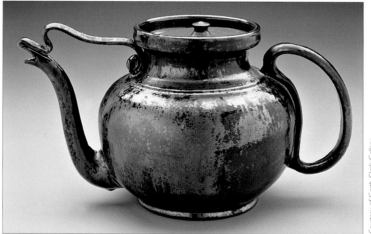

George Ohr, *Teapot*, ceramic, c. 1900, private collection. George Ohr (1857–1918) was the first potter to identify himself as an artist. With his multiple handles and spouts, twisted forms and colorful glazes and a flamboyant lifestyle and unusual marketing techniques, he was well ahead of his time. Ohr died relatively unknown and remained obscure until 1972, when more than 7,000 of his pots were discovered crated away in the family attic. He has since achieved virtually cult status and become a major influence for contemporary artists.

Photo by David H. Ramsey

Courtesy of Garth Clark Gallery

Not all potters have adhered closely to the Leach-MacKenzie model, and most have expanded on the concept with continued exploration and interpretation of British and Japanese influences. American notions of personal expression are evident in the second and third generations as potters have continued to blend the Anglo/Asian style with their own creative aesthetics and with historical American pottery traditions. Warren MacKenzie himself says, "Even my work today would not be suitable at the Leach Pottery." Studio work is no longer as austere, nor is every pot intended for daily use. Likewise, the economic model has changed. As the pots gradually move away from pure function and become sought after by collectors, prices have gone well beyond those of utility items.

While many artists are still connected to the Leach-MacKenzie tradition, much is changing. Vernacular pottery forms used in food and beverage service from New England and the South are now as much an influence as the Anglo/Asian tradition. Dramatic firing effects using wood-fueled kilns, infusions of salt, and other "pyrotechnics" result in vibrant surfaces and rich glaze effects. Probably the greatest departure from the Leach-MacKenzie model is in the area of surface decoration — painterly brushwork, bold monochromatic patterning, elaborate carved imagery and patterned glaze work.

Studio pottery in the South also came under the influence of Leach and designs from Asia. In North Carolina, small potteries supplied the liquor industries with ceramic bottles. After a nearly fatal blow from the onset of Prohibition in 1919 (coupled with the expansion of factory-made china and glass), a cooperative venture, Jugtown Pottery, began producing a combination of traditional Southern pottery and a new line of Chinese-inspired shapes and glazes for Tiffany studios. The success of Jugtown and its location on the north-south highway between New York and Florida revived the region's folk potteries with a steady stream of tourists. Teapots became a popular item, and they remain in production today at many of the 90 or more potteries in Seagrove, North Carolina.

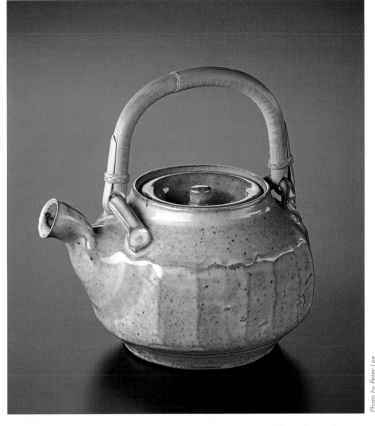

Photo by Peter Lee

Warren MacKenzie, *Teapot*, cut-sided stoneware with Shino glaze, 1996, 7⅝"H x 7"W x 5"D, private collection.

THE NEW AMERICAN TEAPOT

By the 1940s, the shift had begun toward individual expression. Formal education in ceramics in 19th-century America began at the end of the century, but it was not until after World War II that ceramics was taught as a fine art. Until then, the primary emphasis had been on teaching students a wide range of craft technology and training them to become teachers or to work in industrial settings. With the onset of World War II, many European ceramic artists sought haven in America and settled throughout the country, often as teachers in colleges and universities. Gertrud and Otto Natzler, Marguerite and Frans Wildenhain and

Maija Grotell were among those who brought with them European design concepts and Bauhaus ideals that married design to function and equated art and craft. Like Leach, they were devoted to the idea of work as a way of life, and as teachers they influenced a generation of artists who went on to become the next leaders in the growing educational programs at universities and at experimental programs like Black Mountain College in North Carolina.

After World War II, the GI bill changed everything. Veterans entered college in great numbers, as did Korean War veterans years later.

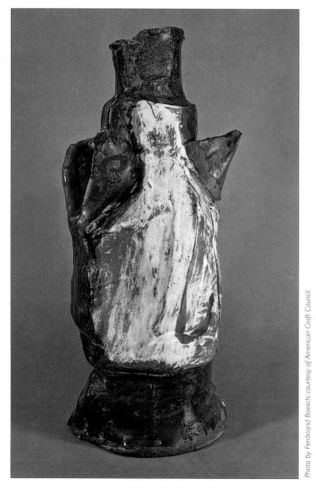

Rudy Autio, *Teapot*, stoneware, 1964, 21"H x 9"W x 9"D, collection of artist.

Photo by Ferdinand Boesch; courtesy of American Craft Council

Burgeoning college enrollments and the rise of adult education programs created a demand for teachers, and universities hired hundreds of artists. Ceramic programs sprang up, as did courses in all craft media at colleges, rural craft schools, art centers and artist cooperatives. Their output led to exhibitions, which were soon followed by marketing opportunities. *Craft Horizons* began publication in 1941 as an "educational service" for the various groups associated with handcraft organizations. Aileen Osborn Webb founded the American Craft Council in 1943 to foster an environment in which craft was understood and valued. These and other regional organizations, schools, publications and expanding exhibition opportunities opened an exchange of ideas that helped to develop a growing national craft community.

Bernard Leach toured the United States for the first time in 1950 and returned in 1952 with Shoji Hamada. Their visits took them to many universities and centers for teaching and producing ceramics. The influence of their visits cannot be overestimated. One artist on whom they had a significant impact was Peter Voulkos, widely acknowledged as creating the model of the ceramic artist as sculptor. Voulkos began his ceramic career with functional wares in the Leach tradition, but he soon combined the teachings of Leach with the spontaneity of abstract expressionist painters and began to work with clay in a completely new way. While teaching in California in the 1960s, he sparked an entire movement and is credited with "destroying" the vessel as it was known. One of his teaching exercises involved making a teapot in two minutes to challenge students' preconceptions. At a time (the 1960s) and a place (the Bay Area) where everything was being examined, analyzed and rebelled against, the humble form of the teapot was not spared.

"The 1960s became the period of experimentation for a new interpretation of the vessel," according to Elaine Levin in *The History of American Ceramics*. The vase was a departure point for ceramic sculptors, and other forms like the cup and the teapot also became fuel for expressive reexamination. But throughout the 1960s, artists began to use the teapot as a medium for artistic expression. In 1965, Paul Smith, the director of the Museum of Contemporary Crafts (now the American

Craft Museum) in New York City, organized an exhibition entitled "The Teapot." The show, he says, was one in a series "that reported on current activities in the craft world. At the time, artists were breaking out of traditional contexts, and many were exploring new directions. . . . We were able to bring attention to individual work through a group presentation." The show included work by Rudy Autio, Karen Karnes, David Mackenzie, Ken Ferguson, Michael Cohen, James Leedy, Peter Voulkos and Richard Shaw and represented the range of work being done at that time, from traditional stoneware influenced by the Bauhaus to Scandinavian and Japanese traditions and irreverent sculptural work. Harriet Goodwin Cohen, in her review for *Craft Horizons* (May/June 1965) said, "A singular theme and a well-chosen group of 23 exhibitors turn this show into a microcosmic revelation of the current American pottery scene . . . which gives rise to some interesting reflections. A new kind of ceramic expression has begun to appear lately, with low firing, bright colors and a sense of humor being joyously rediscovered. Only a complete disregard for function links this new style with the tremendous breakthrough that Voulkos made when he declared that the pot need not after all be a pot." Looking back, she now says of the show, "It was a pivotal time. Things were changing at such a rate that we didn't know it at the time."

In 1969, Robert Arneson produced a series of 35 sculptures in which the teapot was used as a satirical object. Arneson created teapots featuring letters pressed into the surface with commentaries about tea, its customs and its properties. Many pieces used provocative imagery, including one in which he used genitalia for the spout, lips and teeth for the lid and feces as the base. Elaine Levin says Arneson "fueled the [teapot] trend. Artists at that time saw his work and understood from it that the teapot form was something that could suggest a lot of other things than just drinking tea — a form could say more than its function."

Throughout the 1970s, the counterculture's "back-to-the-land" movement drew hundreds of young, college-educated artists into the burgeoning craft movement. New and more readily available technologies, some a result of NASA's growing space program, gave artists access to

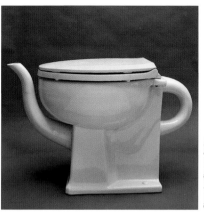

Clayton Bailey, *The Toilet Teapot*, industrial porcelain, 1976, 30"H x 24"W x 24"D, collection of artist. Clayton Bailey says, "*The Toilet Teapot* was made during my first artist-in-residency at the Kohler Company in 1976. I took an unfinished toilet from the production line and added a handle and pouring spout. A standard toilet seat provided a fine lid. My suggestion to the president of Kohler Company, Herb Kohler, was to put it into production so they would have a back-up product if toilets didn't sell during a recession."

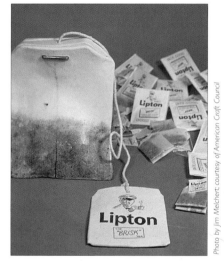

David Mackenzie, *Lipton Tea Bag Teapot*, low-fire clay, glaze and china paint, 1965, 7½"H x 6"W x 4"D, collection of artist.

Richard Shaw, *Mary Jane Teapot*, porcelain and china paints, 1999, 8¼"H x 7¼"W x 2½"D, collection of David and Jacqueline Charak.

advanced equipment and a variety of supplies. Craft shops, galleries and fairs expanded the marketplace for the objects and became important in the exchange of ideas, as did national conferences and magazines. As the teapot became a popular object for artists to explore, galleries began to host theme shows on the subject of teapots, cups and tableware. Collectors paid attention, and by the 1980s a genre was well established.

In 1989, Garth Clark, ceramic historian and dealer, wrote the first book on the subject, *The Eccentric Teapot*. His history of tea and teapots and his examination of the rituals of tea legitimized the growing collections. Clark comments, "The teapot is the favorite single form in ceramics, period. There is no other form that has the same broad appeal. I think that the implied humanity of the teapot and its role is contagious, as well as the 'home and hearth' feeling. Also, it has an insistent anthropomorphic quality that both provokes and delights." The book, voted "pick of the year" by *Time* and *Newsweek*, had a tremendous effect. From that point forward, collecting gained momentum.

With a deepening interest in teapot collecting in the 1990s came economic encouragement for artists. As the decade progressed, artists who had begun to explore the teapot as a form for personal expression pushed their work to new heights. The studio pottery movement gained strength as potters began to market unique pieces outside the "affordable" price range. The craft fair waned as the only means of distributing one-of-a-kind handmade objects, and the gallery system became the primary showcase for work by maturing artists. Likewise, collectors weaned on affordable crafts began to appreciate and seek out more unusual artistic pieces, and a healthy economy permitted them to indulge more cultivated tastes. These factors combined to support the artists' development through the decade.

THE RISE OF THE TEAPOT COLLECTION

Bruce W. Pepich, director of the Charles A. Wustum Museum of Fine Arts in Racine, Wisconsin, says, "The act of searching and selecting appeals to all collectors and intrigues the viewer. It also excites and encourages artists to produce their best work." During the 1980s and 1990s, a few individuals, including Sonny and Gloria Kamm, Donna Moog, Sanford and Diane Besser and David Charak, became major collectors who influenced the development of the genre. Continued support from these and other collectors has fostered the development of teapot design. By sharing and exhibiting their collections of historic

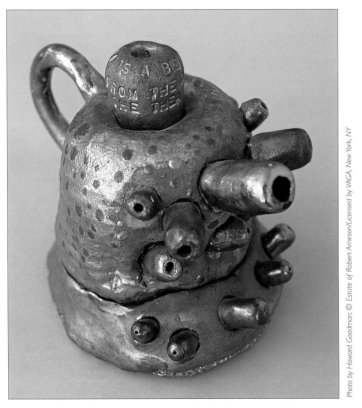

Photo by Howard Goodman; © Estate of Robert Arneson/Licensed by VAGA, New York, NY

Robert Arneson, *Teapot*, ceramic, 1969, 8¼"H x 9½"W x 8"D, collection of Allan Stone. These are the words printed on the lid: "tea is a beverage made from the dried leaves of the thea sinesis plant."

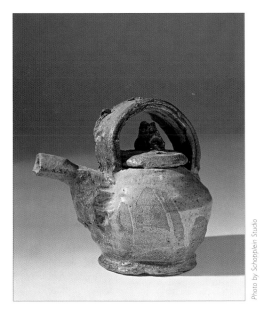

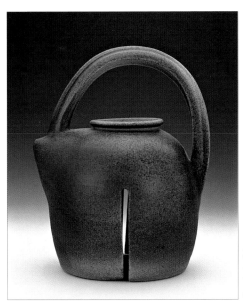

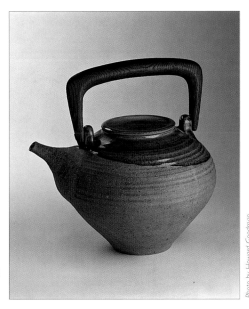

Peter Voulkos, *Teapot*, stoneware and glaze, c. 1959, 7¾"H x 8¼"W, private collection.

Karen Karnes, *Teapot*, wheel-thrown, glazed stoneware, 1989, 12"H x 10"W x 7½"D, The Donna Moog Teapot Collection, Charles A. Wustum Museum of Fine Arts, Racine, WI.

Karen Karnes, *Teapot*, ceramic and wood, 1953, 11¼"H x 11½"W x 9"D, collection of Mikhail Zakin.

and contemporary works, they acquaint artists and the public with the evolution of the teapot and with the distinct creative approaches different artists bring to the same form. In addition, teapot shows and competitions, like the one held annually by Celestial Seasonings, have served to inspire artists working in all media, not just ceramics, to interpret the teapot form. The combined impact of collectors, corporations and institutional interests has resulted in a subgenre of primarily nonfunctional teapots made in precious metals, fiber, beads and other nontraditional materials.

As the 1990s came to a close, private collectors active from 1970 to the present began to donate individual teapots or entire collections to institutions with important collections of contemporary craft and design objects. The teapot has become integrated into private and public collections that span decorative, applied and fine arts, both contemporary and historic. The teapot now encompasses a full range of individual interpretations of the functional object and reflects the general movements in art and design. A new chapter has been added to the long and rich history of this appealing object.

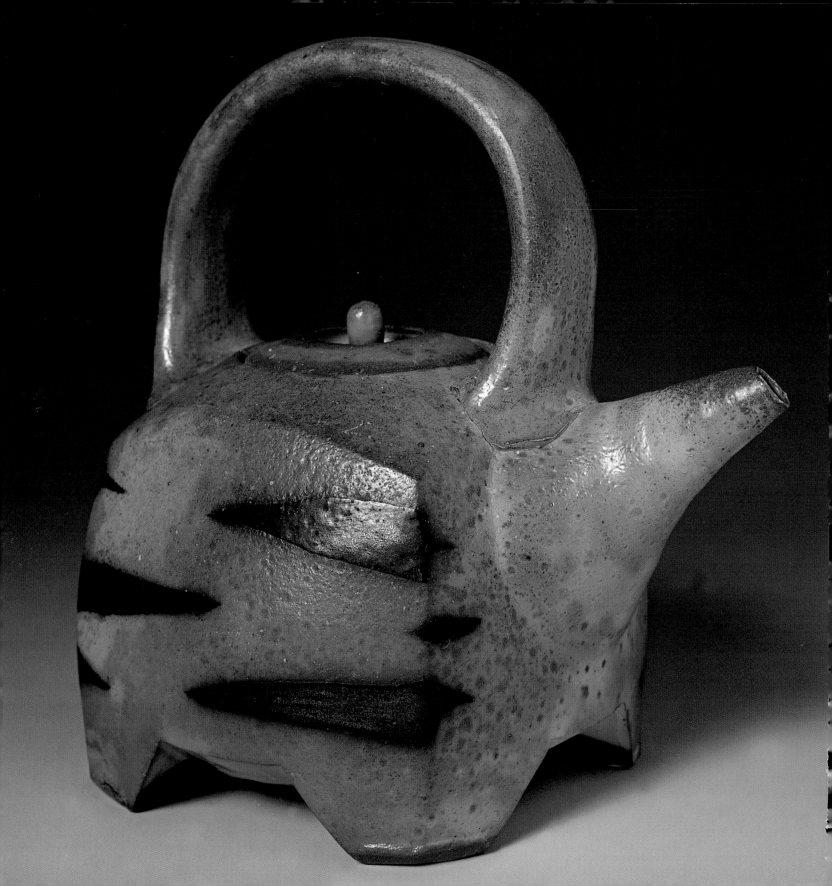

STUDIO POTTERS

S tudio potters work on a small scale, often in rural settings, to produce tableware and useful objects. As their work matures, they may become known for specific designs or glazes, decorative techniques or distinctive approaches to form. While some also call themselves artists, most identify with a craft tradition and use the term *potter* to describe their vocation.

Making and using studio pottery at the start of the 21st century might seem incongruous in a world dominated by mass-produced goods, disposable dishes and take-out food, but the very abundance of standardized commercial wares broadens the market for the personal, the unusual and the original. Potters continue to establish studios and prosper, serving those individuals who prefer their soup served in beautifully thrown bowls and their tea brewed in well-made teapots.

Individuals who create handmade functional pottery may use modern technology like electricity and bottled gas to fire their kilns. They may use powered equipment and have their materials conveniently delivered to their door. Yet the process of making pots remains as it has been throughout history. Pots are still thrown on a wheel or built using hand methods; they are fired and glazed in kilns, which are sometimes fueled by wood; apprentices who are learning on the job share the work; and the finished wares are sold directly to the public or through regional shops and retailers. What has changed in pottery studios is the approach to design. Today, even production potters making functional objects seek out a level of individuality that is more consciously personal than that of their predecessors.

Mark Shapiro, *Teapot*, thrown, paddled, trimmed and wood-fired stoneware, 1999, 8"H x 7"W x 5½"D, private collection. According to Mark Shapiro, "The pots I most admire . . . were made in great quantities by potters who worked every day and fired large woodburning kilns. I follow this practice, not as a formula for making good pots, but because it is the best way I can see to make contemporary pots that have power, presence and purpose."

Ellen Shankin

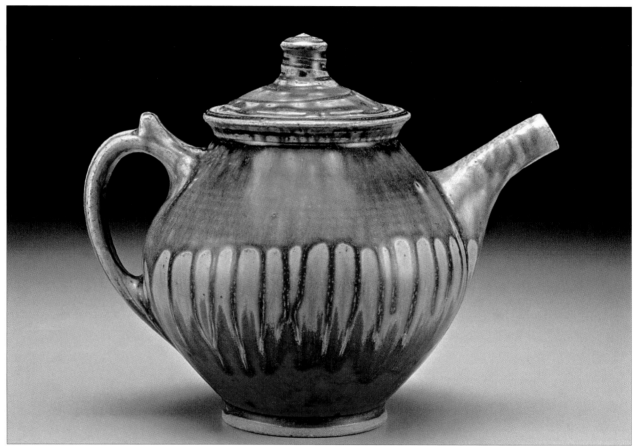

Photo by Tim Barnwell

ARTIST: Ellen Shankin
TITLE: Teapot
DESCRIPTION: Thrown stoneware with ash
glaze, 1999
DIMENSIONS: 8"H x 9"W
COLLECTION: Artist

Photo by Jackson Smith

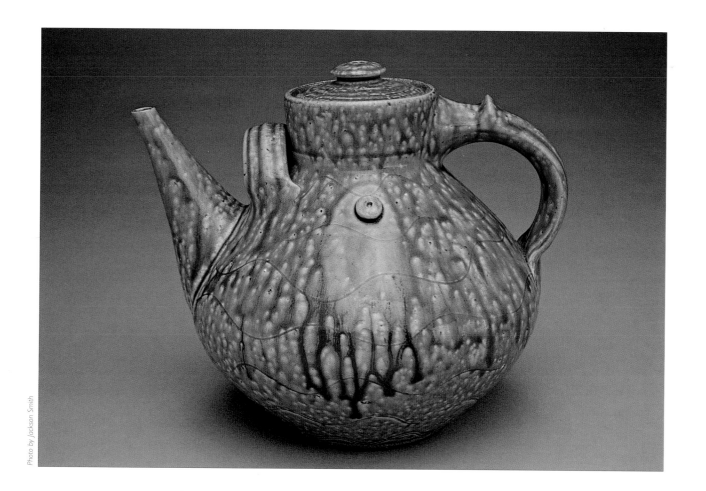

ARTIST: Mark Hewitt
TITLE: Large Teapot
DESCRIPTION: Wood-fired stoneware
with ash glaze and blue glass, 1996
DIMENSIONS: 10"H x 11"W x 10"D
COLLECTION: Private

Linda Sikora

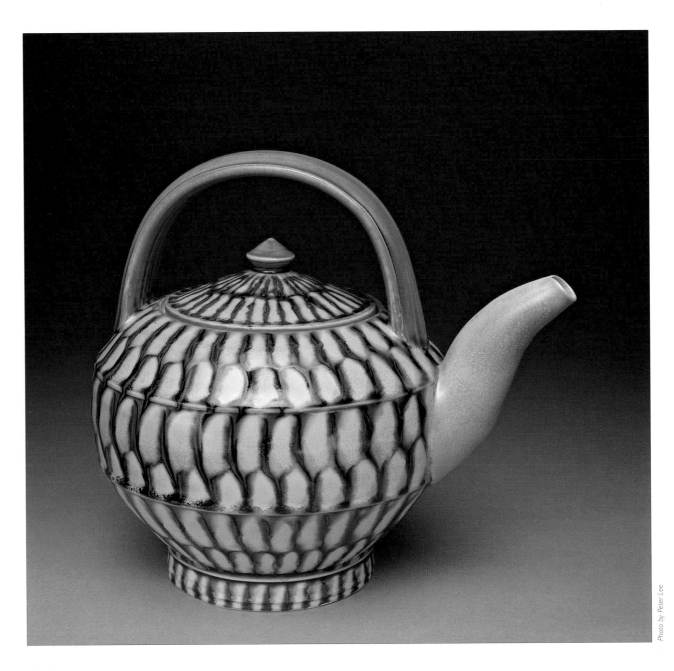

Photo by Peter Lee

ARTIST: Linda Sikora
TITLE: Teapot
DESCRIPTION: Wood, oil and salt-fired porcelain
with polychrome glaze, 1999
DIMENSIONS: 7½"H x 8"W x 6"D
COLLECTION: Private

Albert Hodge

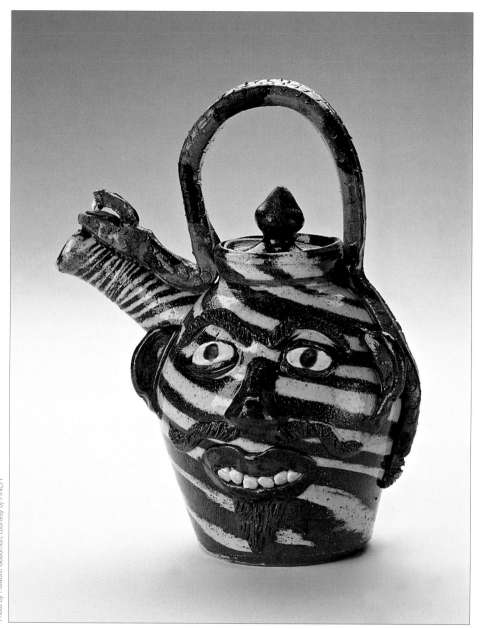

Photo by Howard Goodman; courtesy of PINCH

ARTIST: Albert Hodge
TITLE: Swirl Face Teapot with Snake Handle
DESCRIPTION: Wood-fired ceramic, 2000
DIMENSIONS: 9½"H x 8"W

This snake-handled teapot by the self-taught folk artist Albert Hodge was inspired by the traditional face jugs made for more than 150 years in central North Carolina's Catawba Valley. Using the "swirlware" style, Hodge infuses his humor into creative variations on traditional themes, techniques and forms.

Barbara Walch

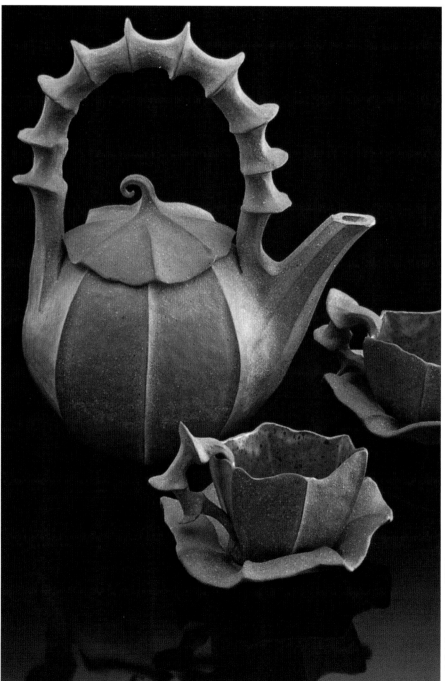

Photo by Susie Cushner, courtesy of PINCH

ARTIST: Barbara Walch
TITLE: A Tea Party
DESCRIPTION: Pinched stoneware, 1993
DIMENSIONS: Teapot: 12"H x 7"W x 5"D, cups:
2"H x 4"W x 3"D
COLLECTION: Jack Lenor Larsen, LongHouse
Reserve

"My pottery is made by hand — by my hands
alone — with the use of a few small hand tools.
I like the tactile experience of immediate and
direct contact with soft, malleable clay. My work
is meant to stimulate the imagination and the
viewer's sense of fantasy while bringing to mind
details of the natural land- or seascape through
organic forms, to renew our sense of connec-
tion to nature. Using the colors of earth and
autumn, the textures of sand and stone, and the
forms of leaves, gourds, shells, seedpods, drift-
wood and flowers ... these are the details of
forest and ocean and of the earth, the source of
our existence."

— Barbara Walch

Jeff Oestreich

Photo by Jeff Oestreich

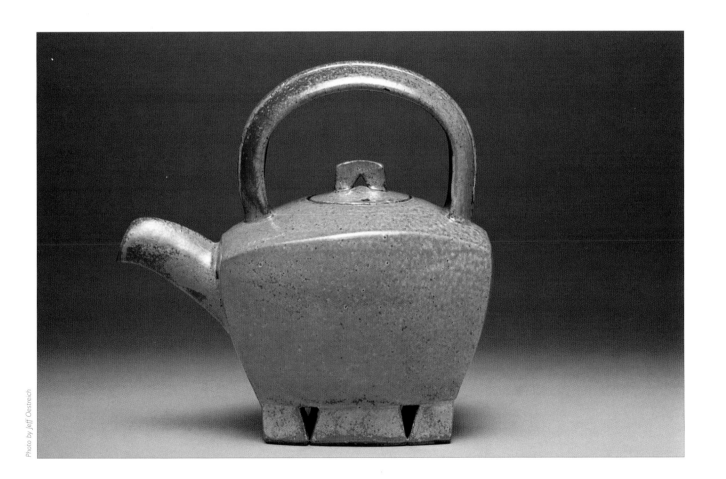

ARTIST: Jeff Oestreich
TITLE: Teapot
DESCRIPTION: Wood-fired stoneware
with yellow glaze, 1990
DIMENSIONS: 8"H x 8"W x 5"D
COLLECTION: Private

25

Randy J. Johnston

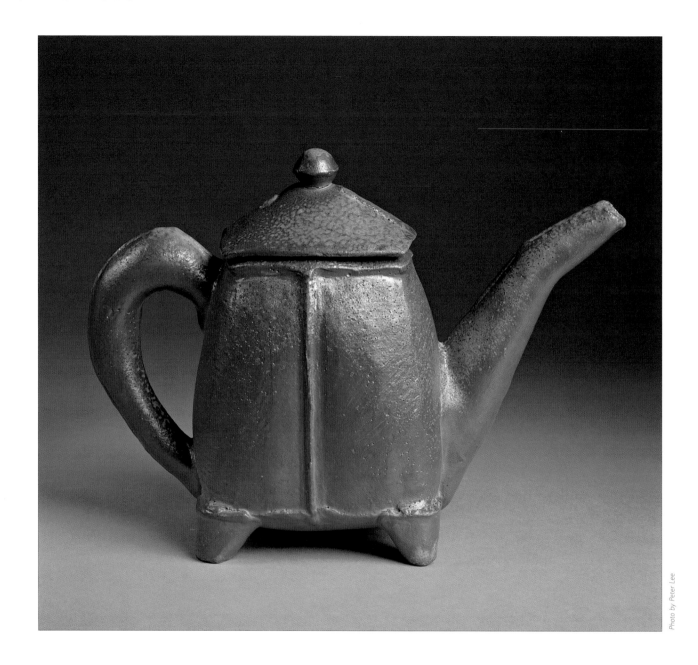

Photo by Peter Lee

ARTIST: Randy J. Johnston
TITLE: Teapot
DESCRIPTION: Wood fired with kaolin slip, 1999
DIMENSIONS: 8"H x 11"W x 5"D
COLLECTION: Private

"The whole notion of (wood) firing the piece is its moment of transformation. When one looks at wood-fired objects, the ideal would be to feel that one is witnessing intimacy and a sense of immediacy and energy — life informed by emotion."

— Randy J. Johnston

Steven Hill

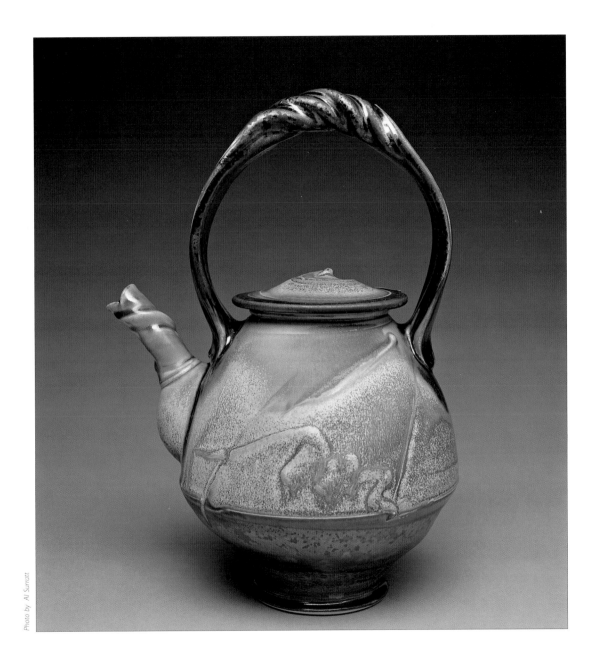

Photo by Al Surratt

ARTIST: Steven Hill
TITLE: Teapot
DESCRIPTION: Thrown and
altered single-fired stoneware, 1999
DIMENSIONS: 14"H x 9"W x 7"D
COLLECTION: Private

Jan McKeachie Johnston

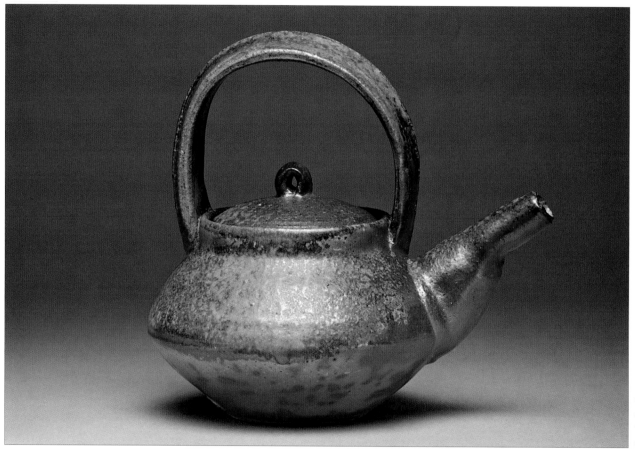

Photo by Peter Lee

ARTIST: Jan McKeachie Johnston
TITLE: Teapot
DESCRIPTION: Wood-fired stoneware, 1997
DIMENSIONS: 8½"H x 8½"W x 6"D

"I am excited by the inherent vitality that clay possesses as a material and about
moving and marking it in a way that brings, I hope, a fresh and immediate feeling
to it."

— Jan McKeachie Johnston

Michael Simon

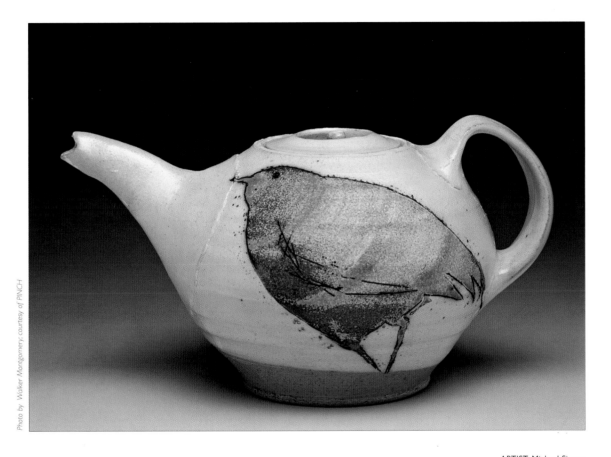

Photo by Walker Montgomery, courtesy of PINCH

ARTIST: Michael Simon
TITLE: Teapot with Yellowbird
DESCRIPTION: Salt-glazed stoneware, 1999
DIMENSIONS: 6"H x 9"W x 6"D
COLLECTION: Private

"I feel it is my job to get those necessary parts —
handle, lid and especially spout — to unite with the
pot shape in harmony. I want them to work and
they must stand for themselves visually."

— Michael Simon

YIXING INFLUENCE AND INSPIRATION

Chinese Yixing (pronounced *ee-shing*) teapots have had a pervasive influence on Western artists since they were first imported to Europe through the tea trade. Yixing ceramics have been produced in China's Jiangsu province since the 16th century using a locally mined fine-bodied dark purple or red clay. The teapots are typically small, scaled for an individual serving. They are formed using basic handbuilding techniques, and it is said that their unglazed surface gives Yixing teapots excellent brewing qualities. The designs are simple but highly functional, and many depict beautiful forms from nature — leaves, fruit, bamboo and animals.

During the Ming (1368–1644) and Qing (1644–1911) dynasties, individual potters created unglazed teapots that were highly valued by the imperial families. While long collected in Korea and Japan, Yixing pottery enjoyed little Western exposure until the opening up of China after the cultural revolution. Today, Yixing artists are again prospering. They have responded to the burgeoning market for teapots, and their work is being avidly collected worldwide. In recent years, many American ceramic artists have visited the Yixing region, about 120 miles outside of Shanghai, to work alongside the masters.

The Yixing model is for some artists a guide, for others an inspiration and point of departure. Many artists in this chapter are directly influenced by Yixing traditions, as shown by their use of clay and forming techniques. Others are only loosely connected in that their work refers to the material world. Teapots in this chapter interpret, mimic and allude to the natural and — at times — man-made world around them. Some American artists, with their access to a broader palette of glazes, use strong, bold colors, while others follow the Yixing style of unglazed ceramics.

Geo Lastomirsky, *Teapot #35,* unglazed terra-cotta, mixed media, 1997, 8½"H x 6¾"W x 12¼"D, collection of Los Angeles County Museum of Art. Geo Lastomirsky says, "I am constantly struck by the sheer majesty of the natural world and the power it has over me. I have tried, in the best traditions of Yixing pottery making and subject matter, to endow my pots with the awe and beauty I feel whenever I spend time 'out there,' just as the Sung dynasty poet-scholars did."

Ah Leon

ARTIST: Ah Leon
TITLE: Up-Right Treetrunk T-pot
DESCRIPTION: Reduction-fired
stoneware, 1993
DIMENSIONS: 17"H x 18"W x 8"D
COLLECTION: Allan Chasanoff
Ceramics Collection, Mint Museum of
Craft and Design, Charlotte, NC

Ah Leon, who is known for his highly
realistic representation of wood in clay,
is a Taiwanese artist who trained in a
traditional Chinese manner. Although
he was already creating contemporary
interpretations of traditional Yixing-style
ceramics when he first visited the
United States in 1987, Leon's work was
permanently changed by his U.S. experi-
ence. His scale grew larger, and his
work became much more expressive
through his exposure to the work of
American artists Marilyn Levine and
Richard Notkin.

Marilyn da Silva

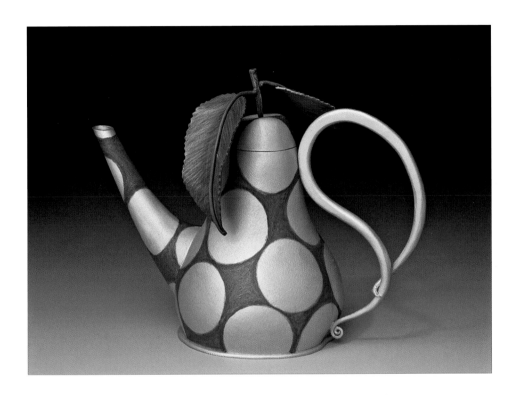

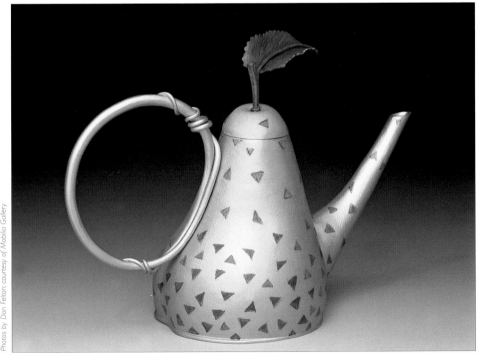

Photos by Don Felton; courtesy of Mobilia Gallery

ARTIST: Marilyn da Silva
TITLE: An Unlikely Pair V
DESCRIPTION: Copper, brass, gesso
and colored pencil, 1999
DIMENSIONS: Each 5"H x 6"W x 3"D

Richard Notkin

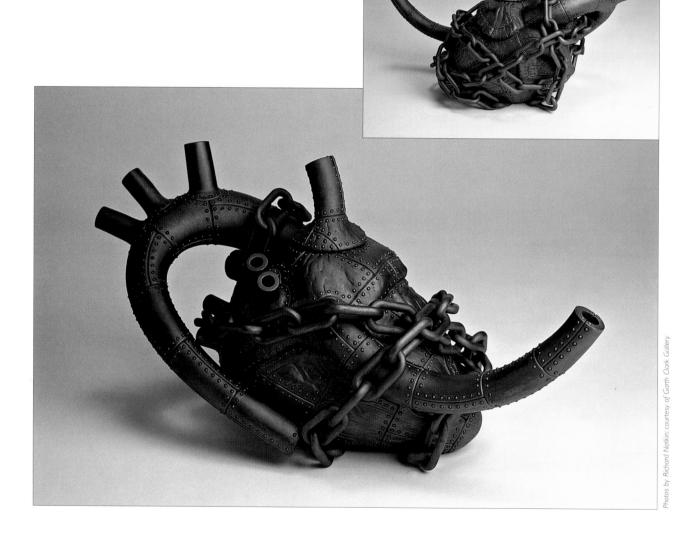

Photos by Richard Notkin; courtesy of Garth Clark Gallery

ARTIST: Richard Notkin
TITLE: Heart Teapot: Ironclad Hostage — Yixing series
DESCRIPTION: Glazed stoneware with lusters, 1988
DIMENSIONS: 6¼"H x 11¾"W x 5½"D
COLLECTION: The Donna Moog Teapot Collection,
Charles A. Wustum Museum of Fine Arts, Racine, WI

Richard Notkin combines Yixing-style techniques with political concerns. His series of *Cooling Tower* teapots commented on the use of nuclear power and the atomic bomb. He followed this with a group of anatomically correct human hearts that explored themes of the horrors of war and the origin of the seed of human conflict — the human heart.

Daniel Anderson

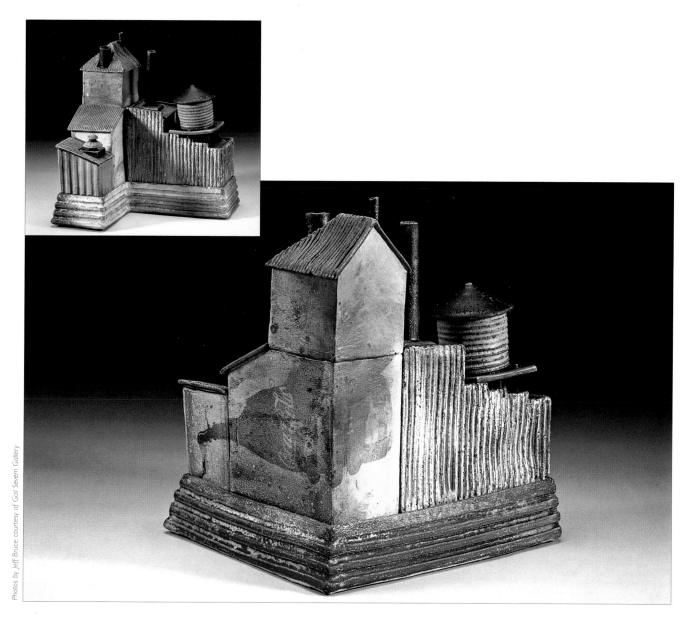

Photos by Jeff Bruce; courtesy of Gail Severn Gallery

ARTIST: Daniel Anderson
TITLE: Water Tower Teaset
DESCRIPTION: Soda-fired and sandblasted stoneware with decal, 1999
DIMENSIONS: 12"H x 14"W x 12"D
COLLECTION: Private

"My artwork, an amalgam of vessel and industrial artifact, is full of irony — hand-made replicas of man-made objects, soft clay renderings of metal objects, aged and impotent reminders of a once powerful age.... The usefulness of machines in their original states is limited — as the products of progress, they're doomed to obsoles-cence — but by re-creating them in a 'primitive' medium, I believe they will endure through the ages."

— Daniel Anderson

Farraday Newsome Sredl

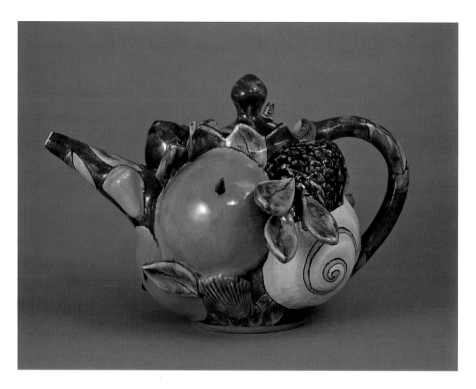

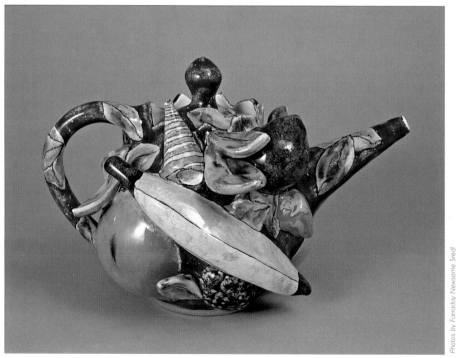

ARTIST: Farraday Newsome Sredl
TITLE: Blue Teapot with Fruit, Pinecones
and Seashells
DESCRIPTION: Glazed terra-cotta, 1999
DIMENSIONS: 8"H x 12"W x 9"D

"My teapots celebrate and affirm the optimism,
sensuality and beauty of the natural world.
Heavily layered glazing allows me a luscious and
painterly surface on the earthy red terra-cotta."

— Farraday Newsome Sredl

Photos by Farraday Newsome Sredl

Eunjung Park

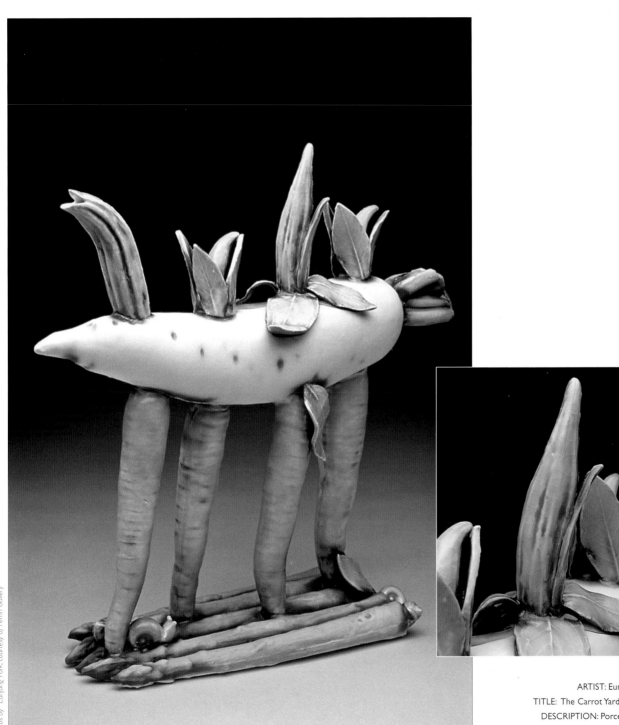

Photos by Eunjung Park; courtesy of Ferrin Gallery

ARTIST: Eunjung Park
TITLE: The Carrot Yard Teapot III
DESCRIPTION: Porcelain, 1999
DIMENSIONS: 12"H x 12"W x 4"D

Richard Swanson

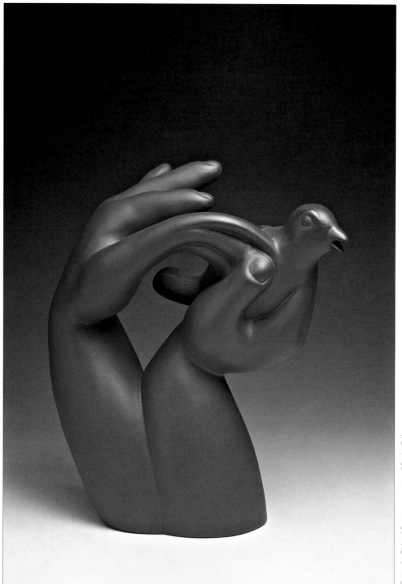

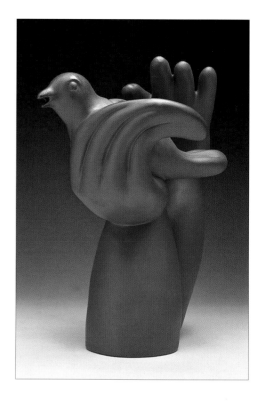

Photos by Richard Swanson; courtesy of Ferrin Gallery

ARTIST: Richard Swanson
TITLE: Bird in Hand
DESCRIPTION: Cast edition, polished, vitreous clay, 1995
DIMENSIONS: 9"H x 8"W x 5½"D
COLLECTION: Los Angeles County Museum of Art

"An important aspect of all my sculptural work, teapots included, is the way forms relate and flow together. I am constantly combining and simplifying to enhance move-ment, rhythm and unity. My teapots are informed by historical examples — Inuit carvings, pre-Columbian ceramics, African sculpture, Japanese netsuke carvings and Yixing teapots. I admire the concise vocabulary of these pieces, their use of everyday life as subject matter, their compact format and their straightforward but unique way of relating figurative elements. In much of this work, the traditions of sculpture and function come together in a way that transcends ordinary ornamentation."

— Richard Swanson

Annette Corcoran

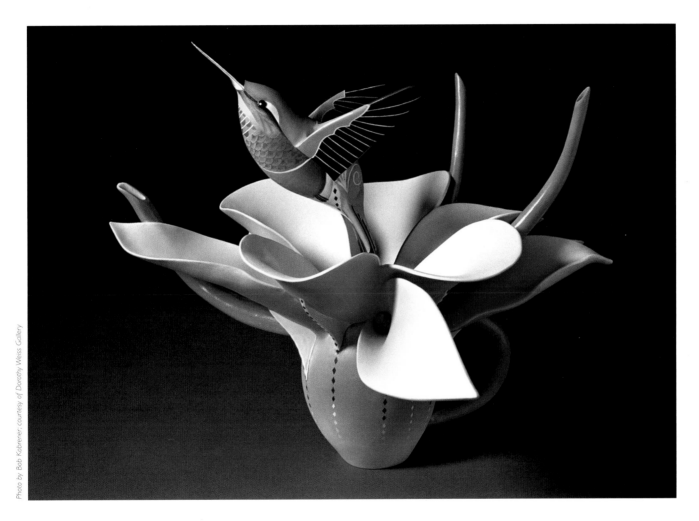

Photo by Bob Kabrener; courtesy of Dorothy Weiss Gallery

ARTIST: Annette Corcoran
TITLE: Hummer II
DESCRIPTION: Porcelain, 1999
DIMENSIONS: 9½"H x 11½"W x 12"D
COLLECTION: Oakland Museum of California Art Department, gift of the Art Guild

"Annette Corcoran believes in using her imagination, fantasies and inspirations in making her innovative teapot forms. . . . The imagery of the bird and the form of the teapot are totally integrated, creating a perfect harmony between two elements, the functional and the aesthetic. Even though water could flow through the teapot, with the beak typically serving as the spout, the functional aspect has been secondary to the sculptural interpretation."

— Dorothy Weiss, Dorothy Weiss Gallery

Joan Takayama-Ogawa

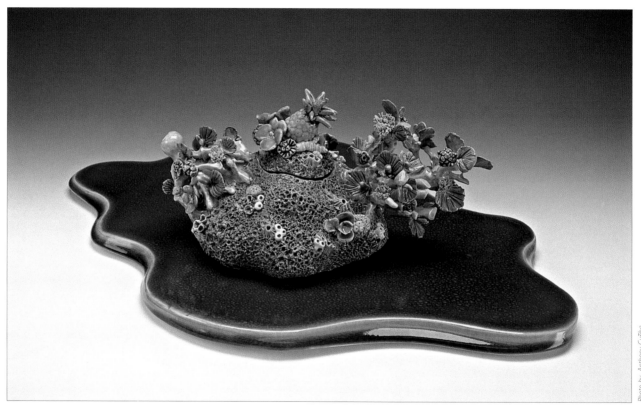

Photo by Anthony Cuñha

ARTIST: Joan Takayama-Ogawa
TITLE: Tropical Paradise
DESCRIPTION: Ceramic, 1996
DIMENSIONS: 5½"H x 18"W x 13½"D
COLLECTION: Sonny and Gloria Kamm

David Furman

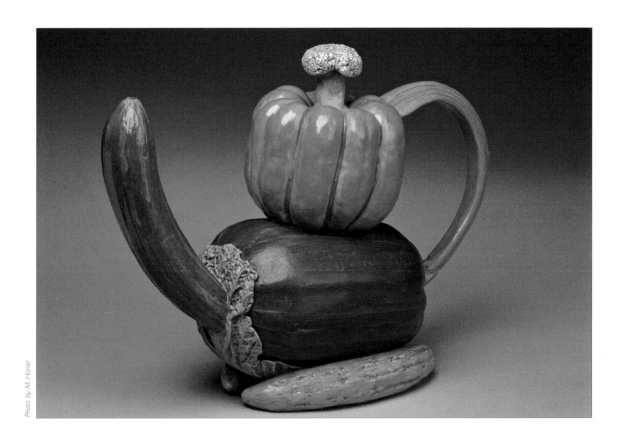

Photo by M. Honer

ARTIST: David Furman
TITLE: Room Service
DESCRIPTION: Porcelain, 2000
DIMENSIONS: 11½"H x 5"W x 15"D

"These vessels carry on in the tradition of the teapot and
the 20,000-year tradition of exploring eroticism, sensuality
and sexuality in art. They address the cultural stigma of
stereotyping issues of fecundity, male virility and power on
the postmodern cusp of the 21st century."

— David Furman

41

Susan Bostwick

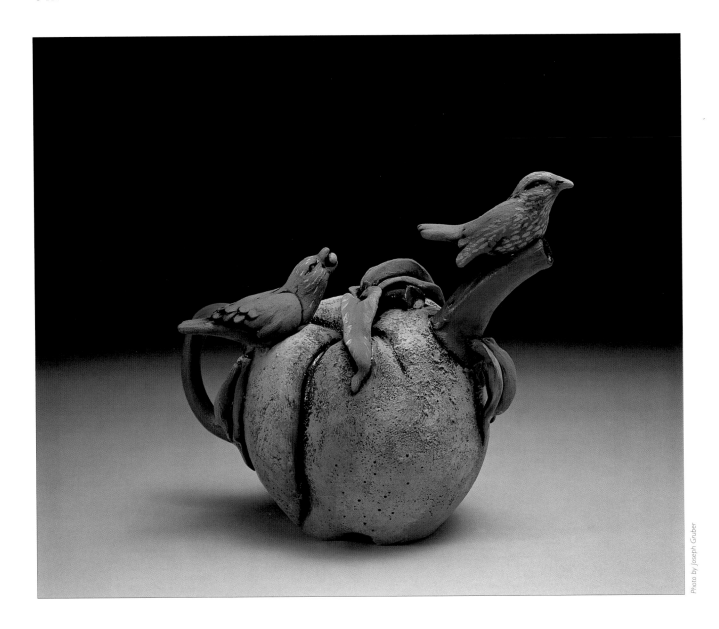

Photo by Joseph Gruber

ARTIST: Susan Bostwick
TITLE: The Offering
DESCRIPTION: Earthenware, 1996
DIMENSIONS: 9"H x 8"W x 6"D
COLLECTION: The Donna Moog Teapot Collection,
Charles A. Wustum Museum of Fine Arts, Racine, WI

Claudia Tarantino

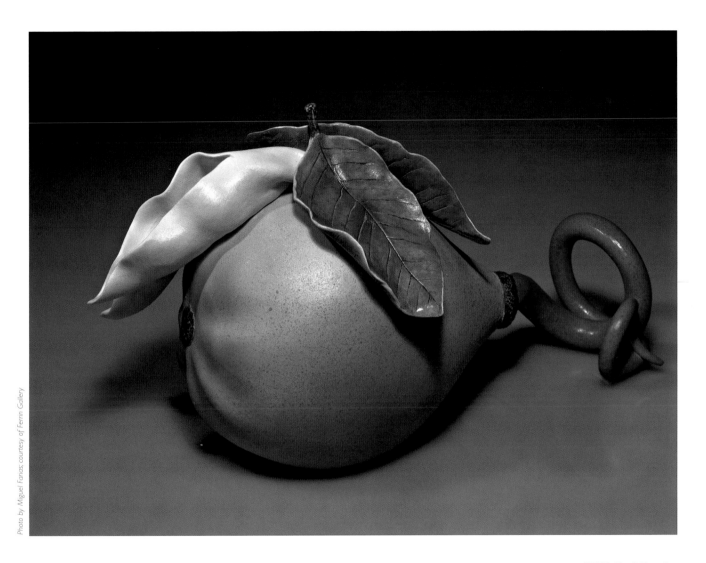

Photo by Miguel Farias; courtesy of Ferrin Gallery

ARTIST: Claudia Tarantino
TITLE: Balloon Fruit Tea
DESCRIPTION: Porcelain, 1999
DIMENSIONS: 7"H x 14"W x 7"D

"My sculptural work in porcelain developed from my earlier career
as a functional potter. As my vessel aesthetic grew, my need for
function diminished, and the vessel format became a springboard
for personal expression. These teapots allude to function, but the
intent is sculptural. This series is inspired by organic forms. Like
ripened fruit, these forms swell with internal energy."

— Claudia Tarantino

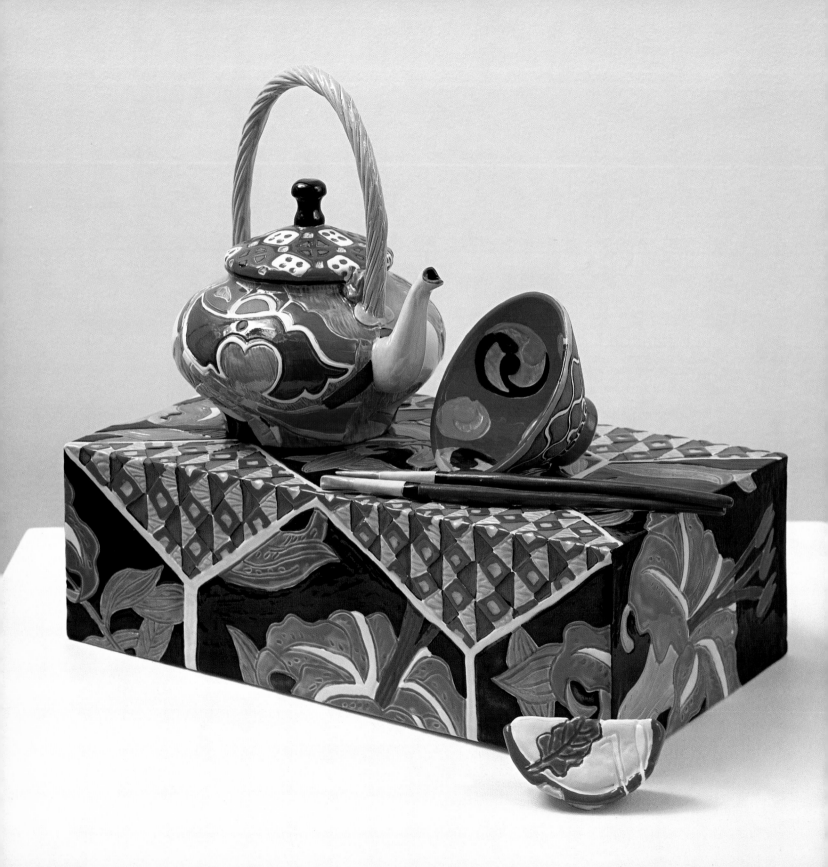

TRIBUTES AND INSPIRATION

Art itself is the source of inspiration for many artists. Specific artworks in history, and commentary on the art world in general, are common themes for contemporary artists working in all media. For those with formal training, art history is a tremendous teaching tool. Through studying or copying favorite works, artists can learn from technical construction and composition and delve into the meaning behind the subject matter. With quality printed images readily available, study is not limited by accessibility to an original work, and computer technology makes it even easier and cheaper to access the world of art. Artists can appropriate images and manipulate them or even use them directly.

For many artists working in two dimensions, recycling or restyling imagery is the departure point for a new artwork. The creator of three-dimensional objects can also draw ideas from historic vessel forms. Some teapots in this chapter refer to specific periods in ceramic history; others include a direct reference to an individual artist or artwork. The artists use these references to comment on our cultural world or convey a narrative focusing on aspects of the history of the teapot. Some artists incorporate within their own work elements, such as a handle or spout, copied from the past. Others invoke a style from a general period as a device for commenting on contemporary issues. In some cases, artists combine elements of found art with their own ceramic work to create a new object.

Karen Koblitz, *Japanese Still Life on Lily Box*, low-fire ceramics, 1990, 12½"H x 14"W x 8½"D, collection of Joan Payden. Karen Koblitz says, "In my ceramic tableaux I play with the juxtaposition of still life objects as well as their surface texture, color and patterning. I refer to the functional roots of ceramics, while elaborating on historical and decorative elements. *Japanese Still Life on Lily Box* was inspired by a summer spent in Japan in the early '70s. I was greatly moved by the beautiful ceramic work of Kenkichi Tomimoto, the colorful woven fabric of the Tatsmura Silk Company and the wonderful wax food displays in the windows of the local restaurants."

Léopold L. Foulem

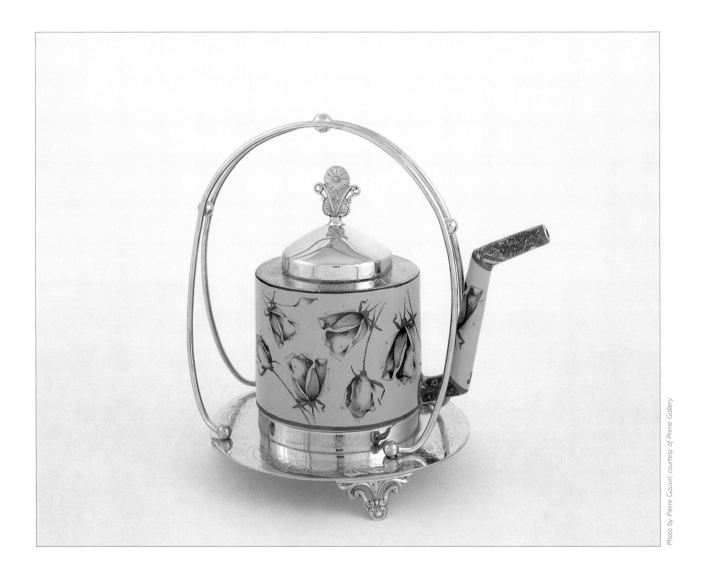

Photo by Pierre Gauvin; courtesy of Prime Gallery

ARTIST: Léopold L. Foulem
TITLE: Yellow Ground Teapot with Roses
in Mounts
DESCRIPTION: Ceramic with found
objects, 1996
DIMENSIONS: 10"H x 11⅜"W x 8"D

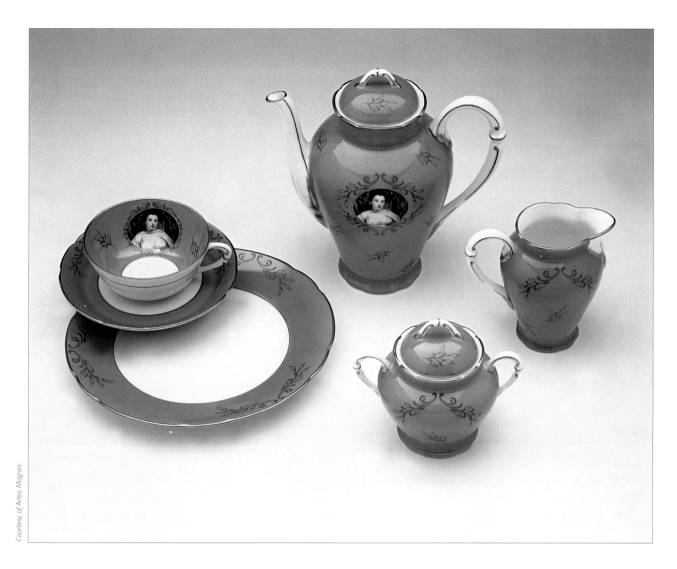

Courtesy of Artes Magnes

ARTIST: Cindy Sherman

TITLE: Madame de Pompadour (nee Poisson)

DESCRIPTION: Porcelain, cast edition, 1990

DIMENSIONS: Teapot: 14½"H x 22"W x 11¾"D

Sherman's image of herself as Madame de Pompadour has been transferred onto porcelain through a complex process that requires up to 16 photo-silkscreens. Each piece is silkscreened and painted at Acienne Manufacture Royale, then individually signed and numbered.

Kelly Torché Hong

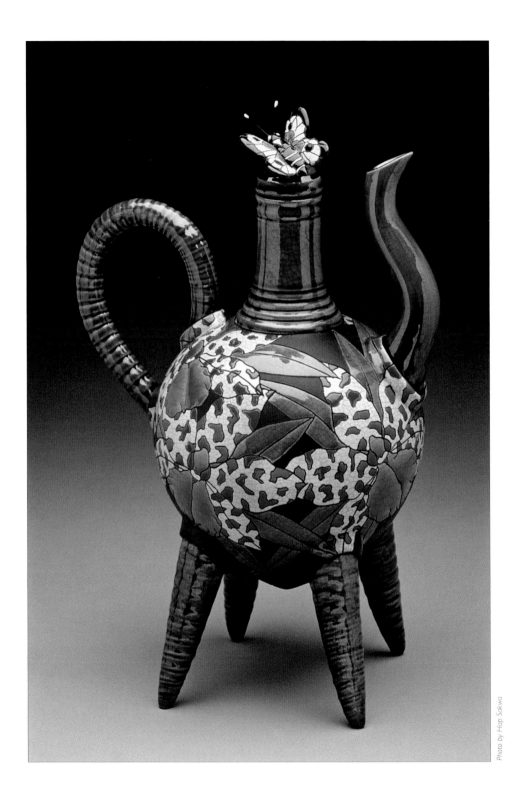

ARTIST: Kelly Torché Hong
TITLE: Teapot with Orchids and Butterfly
DESCRIPTION: Multiple-fired ceramic, 1999
DIMENSIONS: 14"H x 8"W x 6"D
COLLECTION: Private

Photo by Hap Sakwa

48

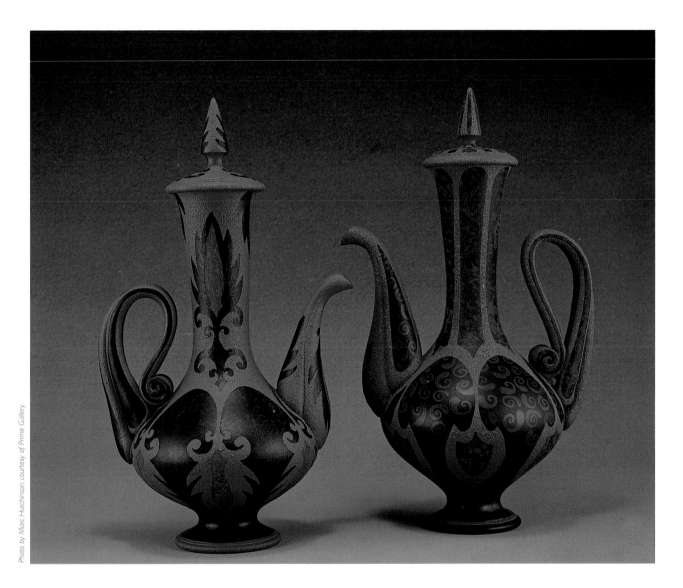

Photo by Marc Hutchinson; courtesy of Prime Gallery

ARTIST: Greg Payce
TITLE: Pair of Teapots
DESCRIPTION: Wheel-thrown red earth-
enware with terra sigillata surfaces applied
in layers using resist techniques, 1998
DIMENSIONS: 12"H x 7½"W x 6"D
COLLECTION: Private

Adrian Saxe

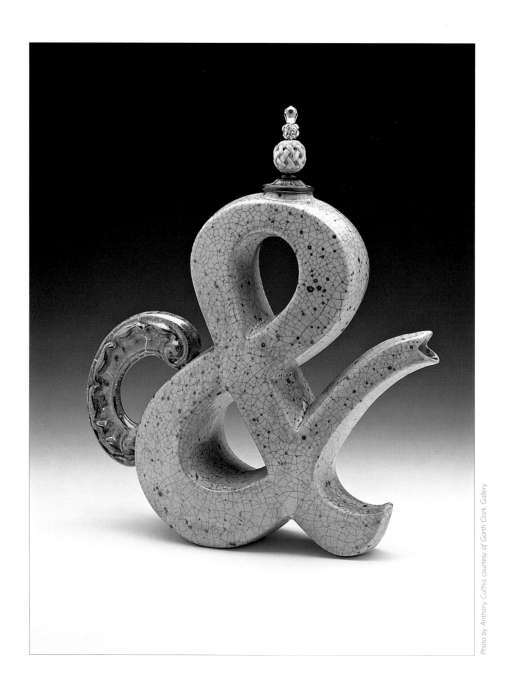

ARTIST: Adrian Saxe
TITLE: Untitled Ewer (Franklin Gothic
Italic Ampersand, DEF)
DESCRIPTION: Porcelain and mixed
media, 2000
DIMENSIONS: 10½"H x 9½"W

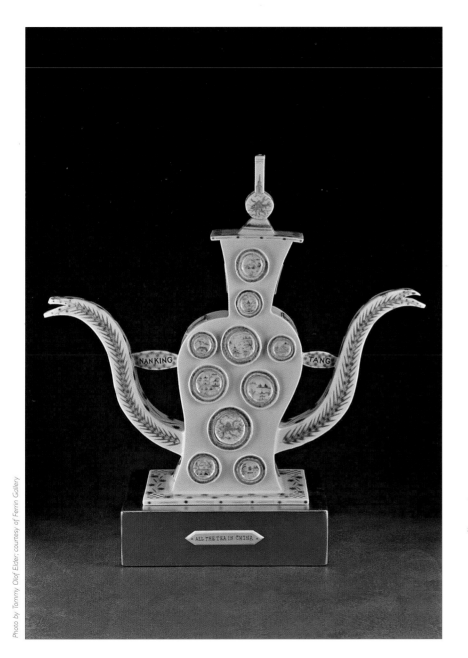

Photo by Tommy Olof Elder; courtesy of Ferrin Gallery

ARTIST: Mara Superior
TITLE: All the Tea in China
DESCRIPTION: Porcelain, bone, wood
and gold leaf, 1997
DIMENSIONS: 19"H x 19"W x 10"D
COLLECTION: Nancy L. Miller

"*All the Tea in China* is a tribute to historic
Chinese porcelains. The body of the pot is an
enlarged exaggeration of a classical Chinese vase
form. It is covered with miniature cobalt blue
Canton plants; the lid is a miniature Chinese vase
that could hold a single flower. The enlarged size
and double spouts symbolize abundance and gen-
erosity. The labels connecting spout to body —
'Nanking,' 'Canton,' 'Ming' — represent towns of
great porcelain production or dynasties of great
significance in ceramic history. The gilded base
supports the metaphor and harkens back to the
notion of the precious and rare qualities of
porcelain, highly prized by Europeans centuries
before Europeans had the know-how to produce
their own porcelains."

— Mara Superior

Bruce Cochrane

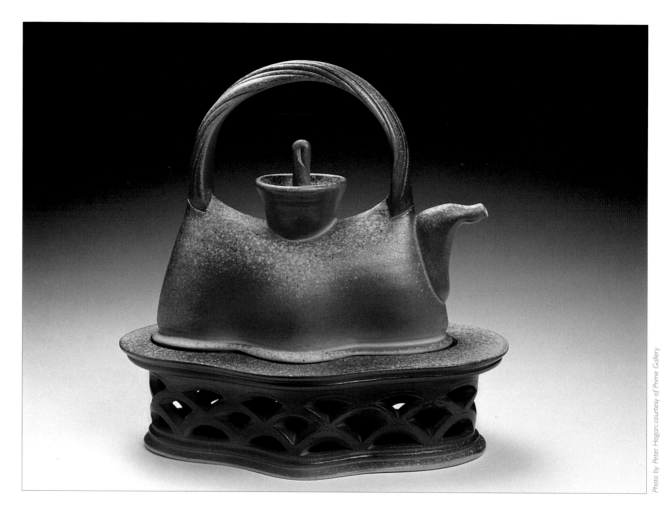

Photo by Peter Hogan; courtesy of Prime Gallery

ARTIST: Bruce Cochrane
TITLE: Teapot and Stand
DESCRIPTION: Wood-fired porcelain,
1998
DIMENSIONS: 9"H x 8"W x 5"D
COLLECTION: Private

"The teapot is a complex relationship of
visual elements and functional require-
ments. An elevated presence and a gesture
to serve are critical to the design of these
forms."

— Bruce Cochrane

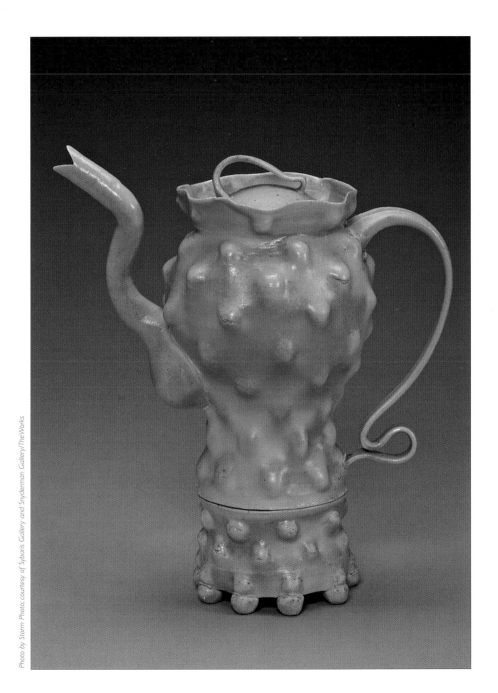

Mary Roehm

Photo by Storm Photo; courtesy of Sybaris Gallery and Snyderman Gallery/The Works

ARTIST: Mary Roehm
TITLE: Teapot with Base
DESCRIPTION: Thrown and altered
wood-fired porcelain, 1999
DIMENSIONS: 9"H x 6"W
COLLECTION: Artist

"The idea that by changing the context in which
an object exists, we change its meaning, allows
me to consider and redefine the vessel. While
exploiting the physical boundaries inherent to
porcelain, a dynamic is created that mirrors the
human condition, the sameness and contradic-
tions that exist between who we are inside and
how we look and express ourselves outside.
Through the process of making, I push the vessel
nearly to the point of collapse. When the work
is finished, and you hold it in your hand, the
softness and symmetry of the form give you the
sense that the clay is still fluid."

— Mary Roehm

Miriam Kaye

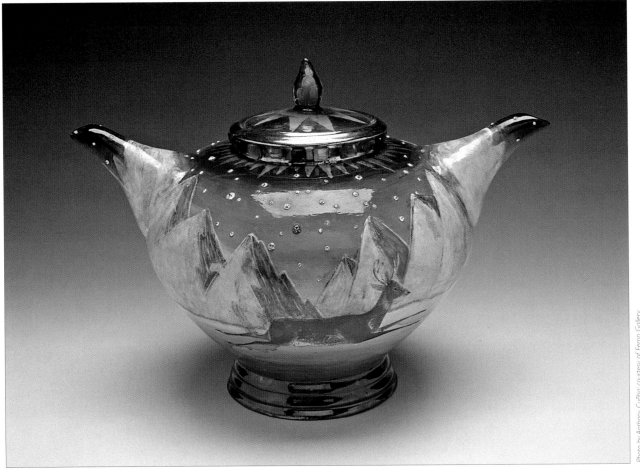

Photo by Anthony Cuñha; courtesy of Ferrin Gallery

ARTIST: Miriam Kaye
TITLE: IMU
DESCRIPTION: Low-fired ceramic using greenware components,
underglazes, glazes, lusters and rhinestones, 1996
DIMENSIONS: 8½"H x 12"W x 8"D
COLLECTION: Sonny and Gloria Kamm

Photos by Clark Kincaid; courtesy of Mobilia Gallery

ARTIST: Kate Anderson
TITLE: Jasper Johns Teapot
DESCRIPTION: Knotted waxed linen, 2000
DIMENSIONS: 9½"H x 10½"W x 3"D
COLLECTION: David and Jacqueline Charak

Susan Beiner

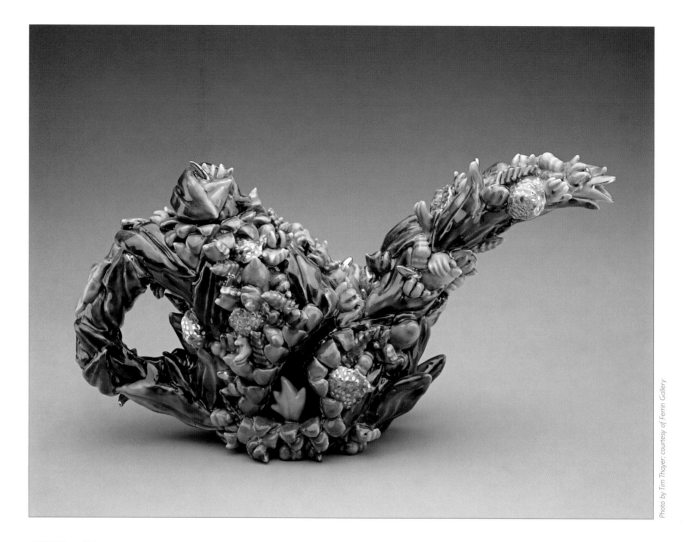

Photo by Tim Thayer; courtesy of Ferrin Gallery

ARTIST: Susan Beiner
TITLE: Funnel
DESCRIPTION: Slip-cast porcelain, 1999
DIMENSIONS: 8"H x 10"W x 6"D

"My work merges contemporary ideas with the forms and traditions of 17th- and 18th-century Meissen and Sevres porcelain. I use castings of common objects as ornamentation, slicing and arranging them in repetitive patterns. By choosing formal objects like teapots, candelabra and soup tureens, I explore the history of the decorative arts. My surfaces imply encrustation of buried objects newly rediscovered."

— Susan Beiner

Beth Katleman

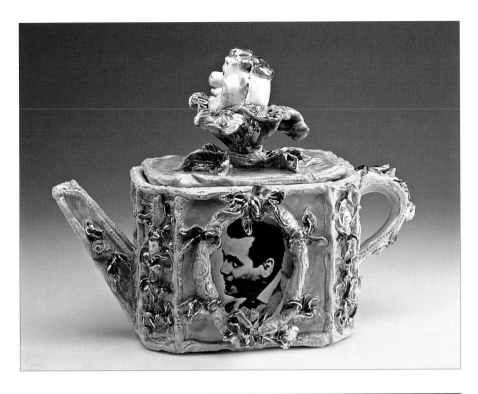

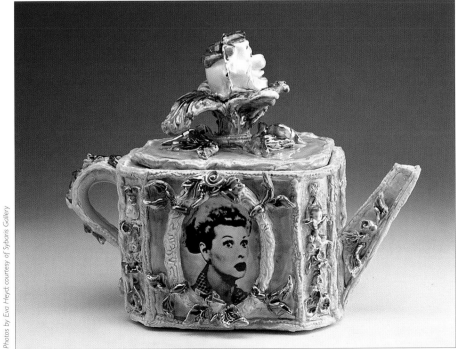

Photos by Eva Heyd; courtesy of Sybaris Gallery

ARTIST: Beth Katleman
TITLE: TV Teapot
DESCRIPTION: Glazed earthenware with
luster and decals, 1998
DIMENSIONS: 11"H x 12"W x 6"D
COLLECTION: Mallery and Steve
Eisenshtadt

"The teapot is vestigial, much like a fire-
place or an appendix. No longer used, it
has become a status symbol much like
royal porcelain. The teapot fuels the
nostalgia for a more 'civilized' time. This
piece, the *TV Teapot*, was inspired by
18th-century porcelain and updated for
the fast-food era. It pays tribute to our
own timeless television royalty. Part
Sevres and part Franklin Mint, the teapot
mythologizes our everyday icons."

— Beth Katleman

Scott Schoenherr

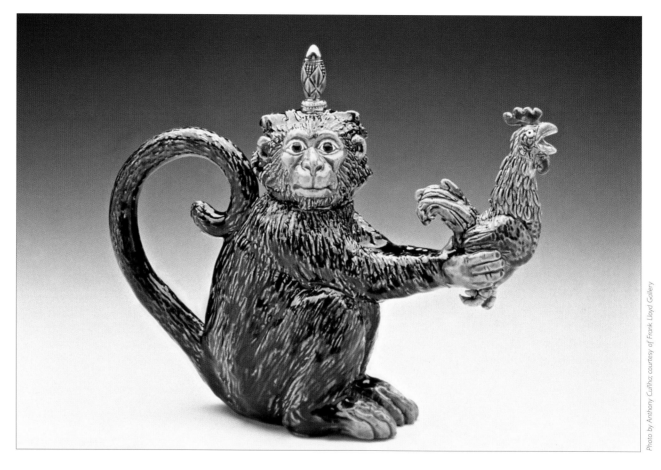

Photo by Anthony Cuñha; courtesy of Frank Lloyd Gallery

ARTIST: Scott Schoenherr
TITLE: Monkey Teapot
DESCRIPTION: Whiteware, 1993
DIMENSIONS: 8½"H x 10"W x 3½"D
COLLECTION: David and Jacqueline Charak

"My art has enabled me to express and analyze issues of time, other cultures and our human role within nature. I use industrial symbols such as gears, cars, airplanes and dollar signs juxtaposed with natural symbols such as animals, plants and ancient carvings. I do this to express the collision course the industrial revolution has had on nature. I use clay as a medium for its historical references to rituals and nobility. I create my work highly detailed and decorative, giving a sense of importance, reminiscent of animistic objects."

— Scott Schoenherr

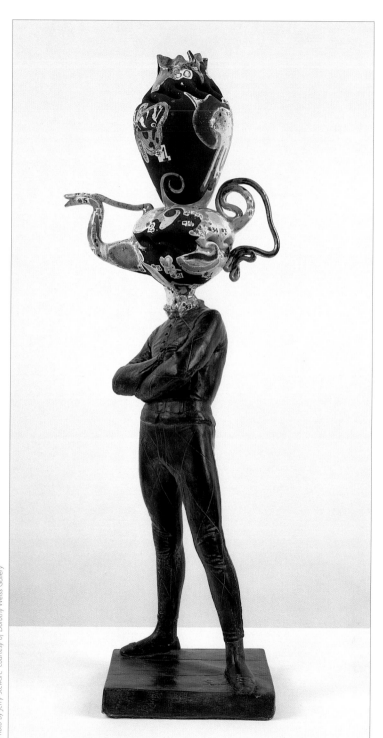

Photo by Jerry Stewart; courtesy of Dorothy Weiss Gallery

ARTIST: Michael Lucero
TITLE: Jester
DESCRIPTION: Clay, glass, plaster and
enamel paint, 1996
DIMENSIONS: 39"H x 13"W x 9"D
COLLECTION: David and Jacqueline Charak

In this piece from Lucero's *Reclamation* series, a
headless statuary is given new life. The ceramic
teapot features many of Lucero's typical references,
iconography and colorful glaze palette. The folds in
the teapot's body and the flamboyant spout and
handle pay homage to the work of George Ohr.

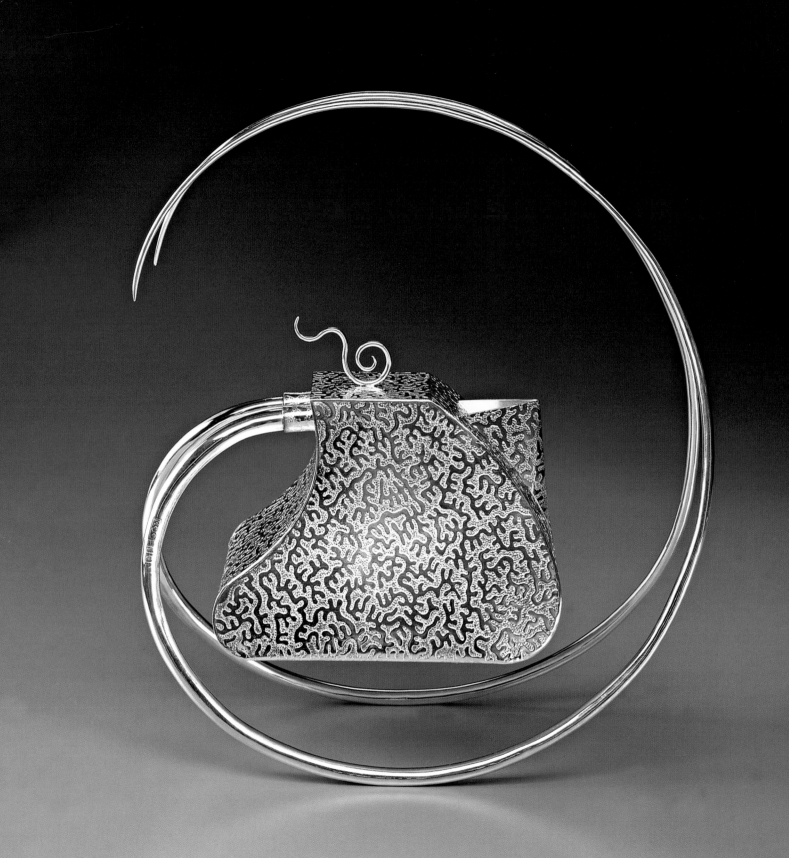

SCULPTURE, PATTERN AND ABSTRACTION

The teapot as a sculptural object can be seen as a dialog between form and surface. In some abstract pieces, the diverse elements that make up the teapot — the spout, handle, body, base, lid — dominate the artistic conversation. Some artists present these elements in their traditional proportions but with hardened or softened edges. Others use exaggeration — stretching out the body horizontally or vertically, diminishing or elongating the spout or handle. Scale becomes an issue as a teapot grows larger: with the oversized object, function becomes vestigial as the question of use becomes moot.

In abstract work, surface is as important as form, and in some pieces it is the primary focus. Glaze is often an artist's signature, as in the rich lusters of Beatrice Wood. Alternatively, the surface can be integrated into and complement an already abstracted form, as in the colorful alkaline glazes and gilded surfaces of Michael Sherrill, which are faceted to create an appearance of light and shadow. For artists like Kevin O'Dwyer, the highly reflective surface of silver can be manipulated into a variety of textures, patterns or polishes. Bennett Bean uses the contrast between gilded and painted surfaces on the various geometric planes of his forms.

Peter Shire and Dorothy Hafner are two artists whose work was particularly significant and who became stylistic leaders in the realm of abstraction and surface design during the 1970s. During this period, Shire produced a great number and variety of teapots that used abstracted elements, strong colors and implied movement. He later became closely identified with the Memphis design movement in Milan, Italy, which was known for its use of bright colors and strong lines. Hafner's signature style of pattern and decoration using colorful modular shapes reached an international audience when she became a designer for Rosenthal AG and Tiffany & Co.

Kevin J. O'Dwyer, *Sleepytime Rocking Teapot*, sterling silver, 1999, 10"H x 10"W x 4"D, collection of Celestial Seasonings.

Photo by Russell McDougal

Patrick Horsley

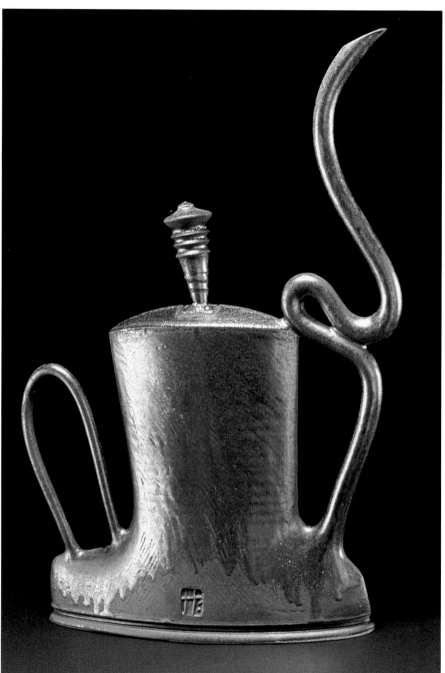

ARTIST: Patrick Horsley
TITLE: T-POT, Bronze
DESCRIPTION: Thrown and altered
stoneware, 1999
DIMENSIONS: 22"H x 17"W x 5"D
COLLECTION: Private

Photo by Courtney Frisse

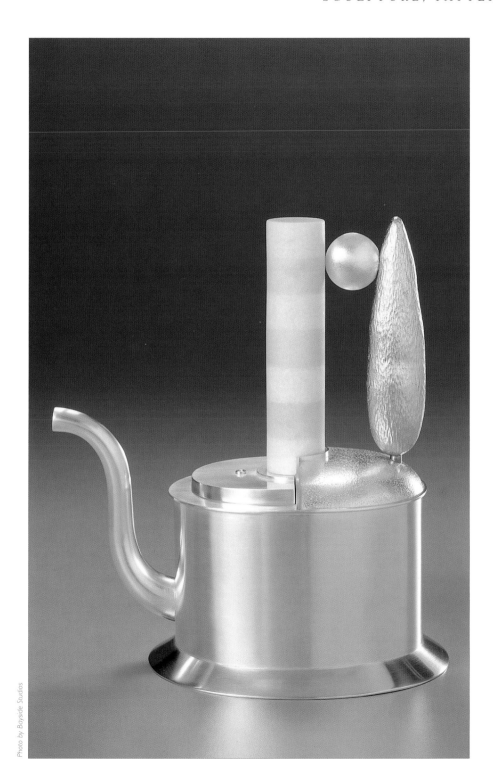

Photo by Bayside Studios

ARTIST: Randy Long
TITLE: Tuscany Teapot
DESCRIPTION: Sterling silver, carved and
laminated marble, wood with gold leaf,
18K gold and smithed and fabricated
forms with roller-printed texture, 1990
DIMENSIONS: 8"H x 7½"W x 4⅝"D
COLLECTION: Lynn Burnside Smith II

"*Tuscany Teapot* was inspired by an evening stroll
in the town of Orvieto, Italy. As I emerged
from a narrow street onto the piazza, I was
stunned by the drama of the full moon
suspended between the stripped marble walls of
the cathedral and an enormous cypress tree."

— Randy Long

Harris Deller

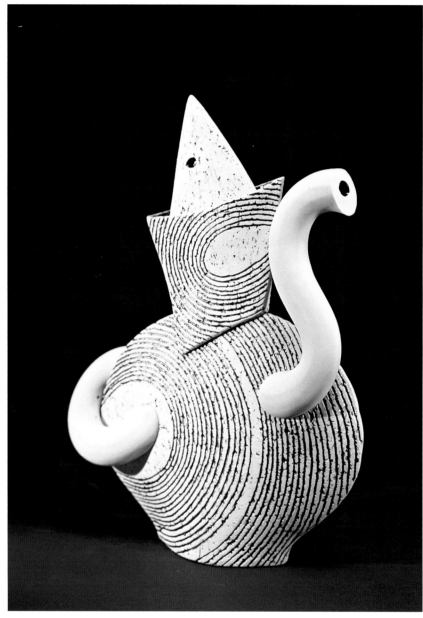

Photo by Harris Deller; courtesy of Ferrin Gallery

ARTIST: Harris Deller
TITLE: Untitled Supressed Teapot
DESCRIPTION: Porcelain, 1998
DIMENSIONS: 14"H x 11"W x 2¾"D

"The teapot is an icon, or portrait with symbolic qualities. It is easily recognizable and approachable, thus rendering it accessible and open to both the maker's and viewer's influences."

— Harris Deller

Kathryn Sharbaugh

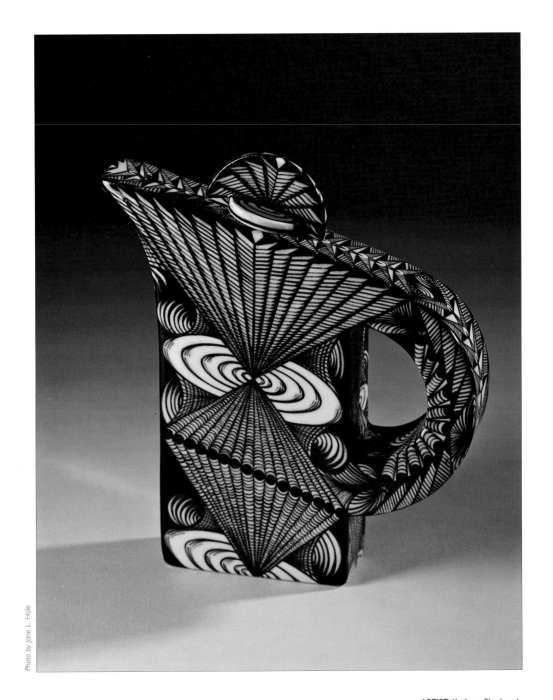

Photo by Jane L. Hale

ARTIST: Kathryn Sharbaugh
TITLE: Night Jump
DESCRIPTION: Porcelain, 1999
DIMENSIONS: 8"H x 6"W x 1½"D

Michael Sherrill

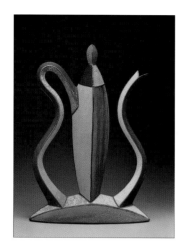

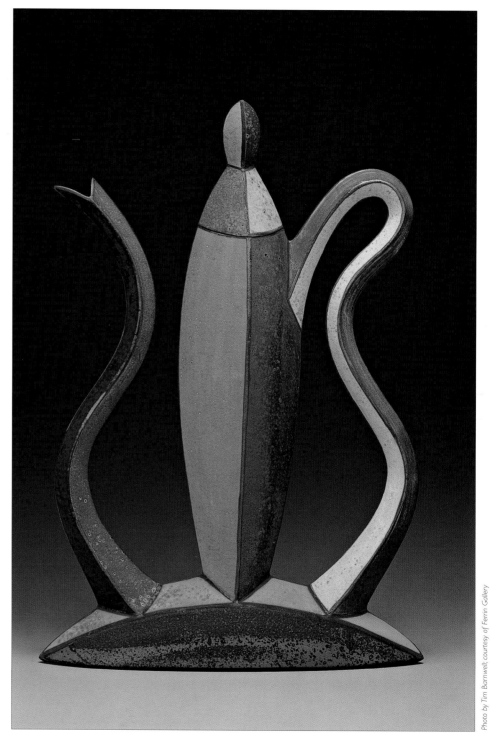

ARTIST: Michael Sherrill
TITLE: Incandescent Tea
DESCRIPTION: Thrown, altered and
extruded stoneware with colored
alkaline glaze, 1997
DIMENSIONS: 21"H x 18"W x 6"D
COLLECTION: Marsha Madorsky

A self-taught potter, Sherrill combines
references to archetypal forms and shapes,
such as Southern whiskey jugs, with con-
temporary design. He reassembles the
teapot's basic elements, forming them into
a sculptural object, by explorations in the
use of color, surface, line and shape. Sherrill
says, "I want my pots to pull people in and
then play with perceptions."

Photo by Tim Barnwell; courtesy of Ferrin Gallery

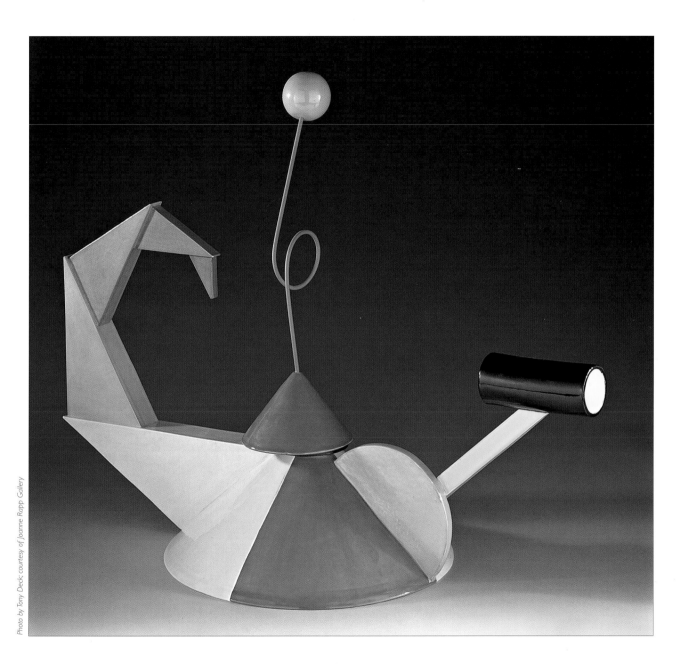

Photo by Tony Deck; courtesy of Joanne Rapp Gallery

ARTIST: Peter Shire
TITLE: Scorpion Teapot
DESCRIPTION: Ceramic, 1982
DIMENSIONS: 18"H x 24"W x 12"D
COLLECTION: David and Jacqueline Charak

Ralph Bacerra

CHAPTER FIVE

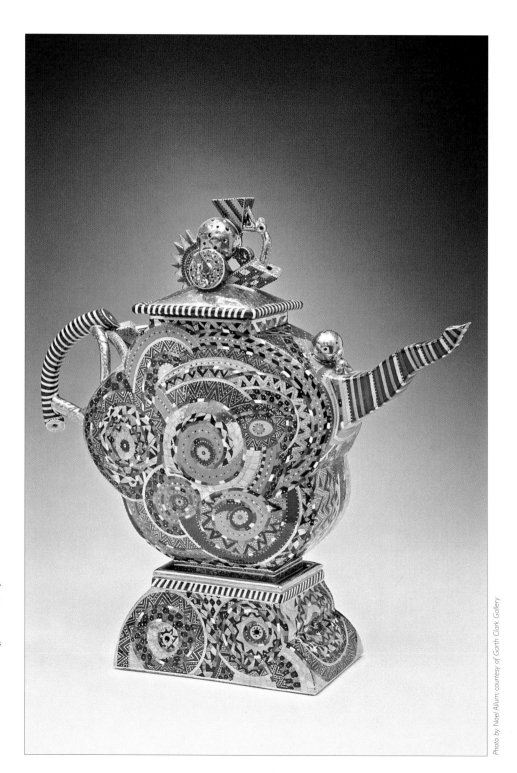

ARTIST: Ralph Bacerra
TITLE: Cloud Teapot
DESCRIPTION: Whiteware, 1998
DIMENSIONS: 29"H x 20"W
COLLECTION: Private

"Unapologetically a decorative artist, Bacerra's muses were the potters who centuries ago decorated Japanese palace wares of Kutani, Nabeshima and Imari with their masterful use of surface decoration, often inspired by the pattern on fabric design. His fine arts affinities tend towards optical systems and stylization, a mix of M.C. Escher (without its mechanistic elements) with a dash of Warhol."

— Garth Clark, *Ralph Bacerra,* Garth Clark Gallery, New York, 1999

Photo by Noel Allum; courtesy of Garth Clark Gallery

James E. Binnion

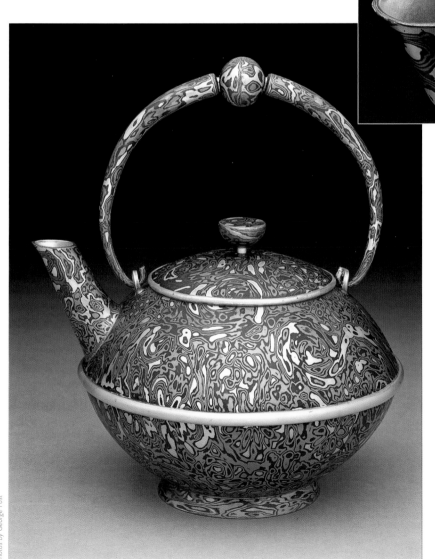

Photos by George Post

ARTIST: James E. Binnion
TITLE: Mokume Teapot
DESCRIPTION: Silver, copper and brass, 1998
DIMENSIONS: 7"H x 5"W x 5"D

"The Japanese words *mokume gane* translated
mean 'wood eye metal.' Denebei Shoami, a
17th-century master metalsmith, credited with
the invention of the process, used it for the
adornment of samurai swords. I have developed
my own modern method of this process, fusing
silver and copper alloys together in a kiln. I
then take the sheet that is formed by many
repetitions of hand carving and forging and,
using a combination of modern and traditional
metalsmithing processes, form the teapot."

— James E. Binnion

Chris Gustin

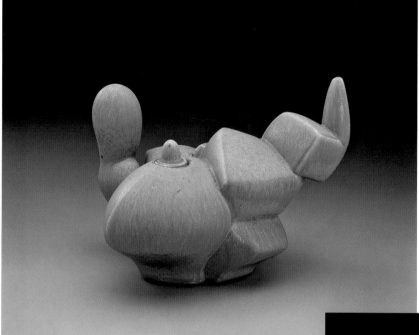

ARTIST: Chris Gustin
TITLE: Teapot
DESCRIPTION: Wheel-thrown stoneware with coil
construction, 1996
DIMENSIONS: 11"H x 14"W x 11"D
COLLECTION: Jacalyn Egan

ARTIST: Chris Gustin
TITLE: Teapot
DESCRIPTION: Wheel-thrown stoneware with coil construction, 1995
DIMENSIONS: 12"H x 12"W x 10"D
COLLECTION: Charles A. Wustum Museum of Fine Arts, Racine, WI; permanent
collection, gift of Dale and Doug Anderson

"Though most of my work only alludes to function, I am trying to make pots that
speak to a 'body' reference. I use the pot context because of its immense possi-
bilities for abstraction. The skin of the clay holds the invisible interior of the ves-
sel. How I manipulate my forms 'around' that air — constraining it, enclosing it
or letting it expand and swell — can allow analogy and metaphor to enter into
the work."

— Chris Gustin

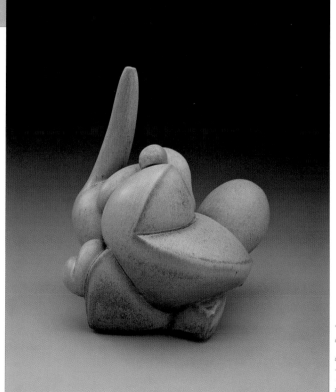

Photos by Dean Powell

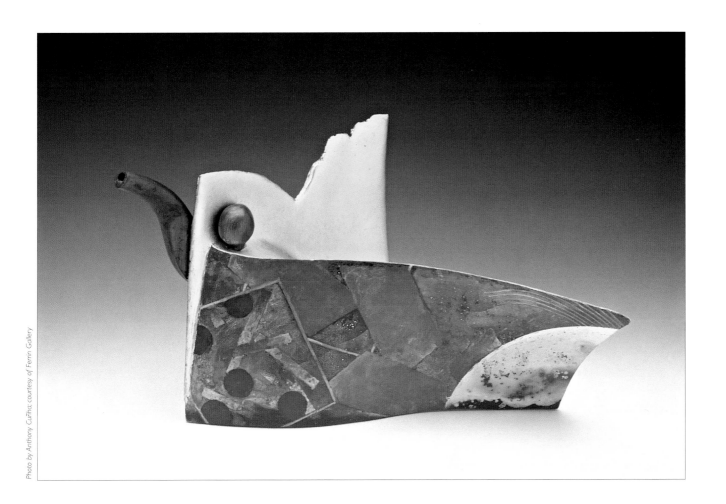

Photo by Anthony Cuñha; courtesy of Ferrin Gallery

ARTIST: Bennett Bean
TITLE: Untitled Teapot
DESCRIPTION: Pit-fired earthenware with
acrylic, gold leaf and epoxy, 1995
DIMENSIONS: 7"H x 14½"W x 3"D
COLLECTION: Sonny and Gloria Kamm

Dorothy Hafner

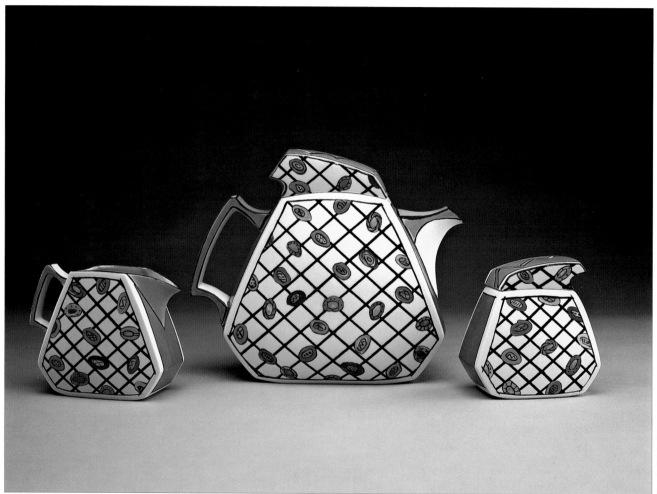

Photo by S. Baker Vail

ARTIST: Dorothy Hafner
TITLE: Satellites (White)
DESCRIPTION: Slip-cast porcelain with underglaze
decoration, 1984
DIMENSIONS: Teapot: 8½"H x 10¾"W x 4½"D,
creamer: 4½"H x 5¾"W x 2¾"D,
sugar bowl: 5"H x 4¾"W x 2¾"D
COLLECTION: Artist

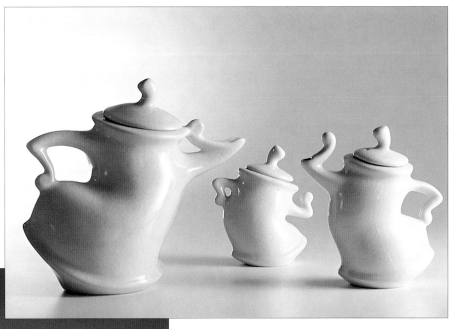

ARTIST: Michael Lambert
TITLE: The Bebop Tea Set,
Crackle White Glaze
DESCRIPTION: Cast porcelain,
original 1999
DIMENSIONS: Teapot: 7"H x
10"W x 5"D, creamer: 6"H,
sugar bowl: 6"H

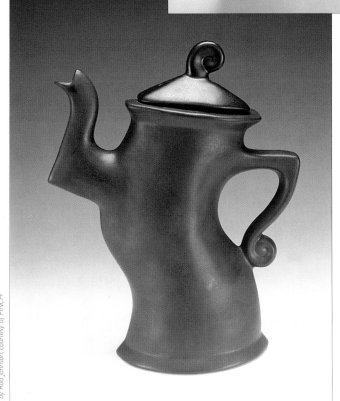

Photos by Rod Johnson; courtesy of PINCH

ARTIST: Michael Lambert
TITLE: Struttin' Teapot, Black Satin Matte Glaze
DESCRIPTION: Cast porcelain, original 1996
DIMENSIONS: 9"H x 10"W x 4"D

Susan R. Ewing

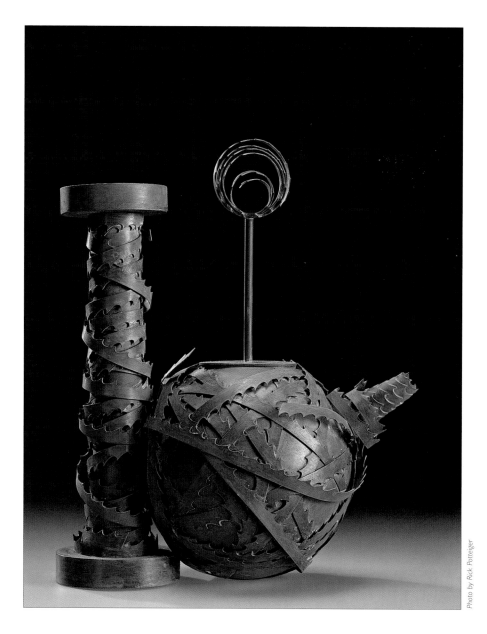

Photo by Rick Potteiger

ARTIST: Susan R. Ewing
TITLE: Ex Voto to St. Eligius Series: Bandsaw Teapot
DESCRIPTION: Sawn, formed and fabricated sterling silver and sheet metal with chemical patina and oil pastels, 1993
DIMENSIONS: 10"H x 8½"W x 4¾"D

"The teapot is a unique typology in the design vocabulary — what other object holds so much international, political, social and cultural history, and yet remains relevant within our contemporary daily life? For me, the teapot provides the ideal vehicle for ironic explorations of space and time, performance, service and ritual."

— Susan R. Ewing

David Damkoehler

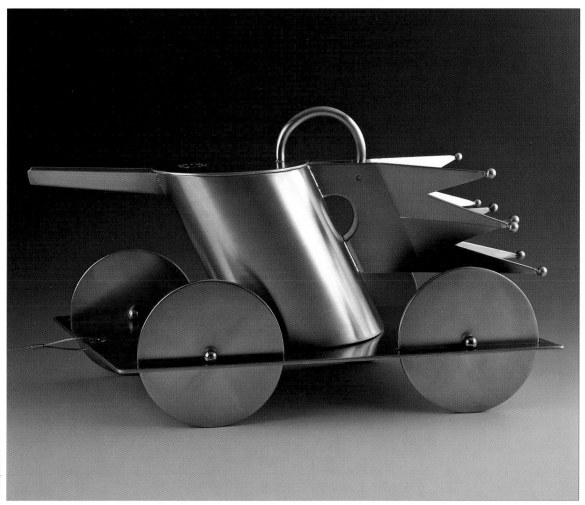

Photo by Michael Mau

ARTIST: David Damkoehler
TITLE: Fast Lane Teapot
DESCRIPTION: Stainless steel, 1998
DIMENSIONS: 18¾"H x 7"W x 11"D
COLLECTION: Sonny and Gloria Kamm

"At first sight, my metal objects look like exotic devices or maquettes for sculpture. I am committed to a highly original investigation of metal crafts. When working on a piece, I raise questions about appearances and taxonomy."

— David Damkoehler

Michael Boyd

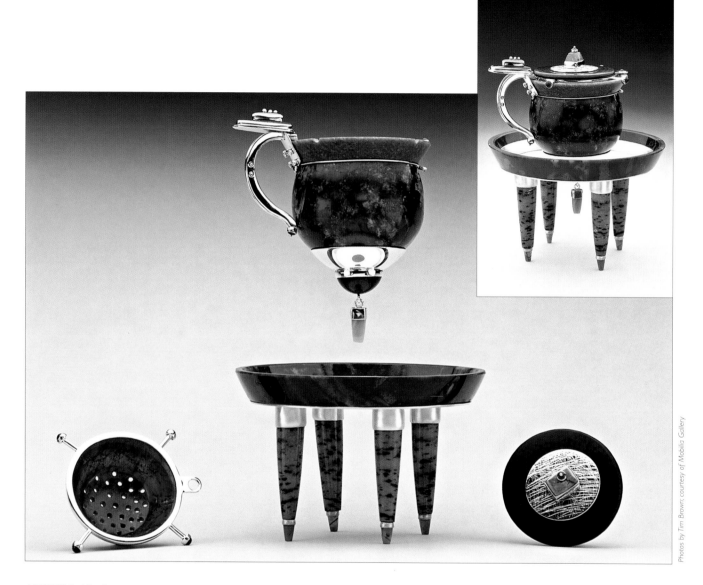

Photos by Tim Brown; courtesy of Mobilia Gallery

ARTIST: Michael Boyd
TITLE: Single Service
DESCRIPTION: Sterling silver, 22K and
14K gold and precious and semiprecious
stones, 1999
DIMENSIONS: Overall: 7"H x 4"W x 4"D,
cup: 2½"H x 3"W x 2½"D,
lid and strainer: ½"H x 2"D,
stand: 4"W x 3½"H x 4"D

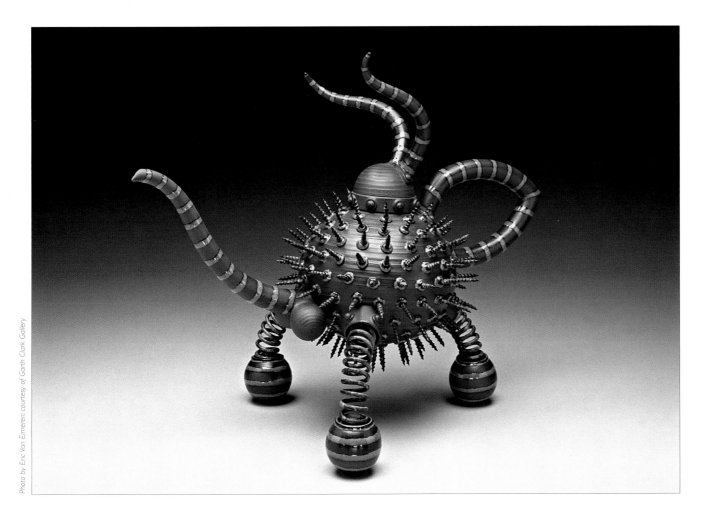

Photo by Eric Van Eimeren; courtesy of Garth Clark Gallery

ARTIST: Eric Van Eimeren

TITLE: Urchin Teapot

DESCRIPTION: Stoneware and steel, 1997

DIMENSIONS: 11"H x 13"W

COLLECTION: Diane and Sandy Besser

"I enjoy the challenge of finding innovative solutions to the centuries-old problems regarding functional ceramics. I am inspired by the fact that despite thousands of years of pottery making, we can still leave our studios today having created something new. My approach employs both 'flintstone' technology and the precision of mechanical engineering. The juxtaposition of biological and industrial elements makes my work simultaneously familiar and disparate. The idea of form following function still rings true; however, I believe that function can, at times, be persuaded to follow sculptural form, thus creating an interesting dialogue between utility and sculpture."

— Eric Van Eimeren

77

Woody Hughes

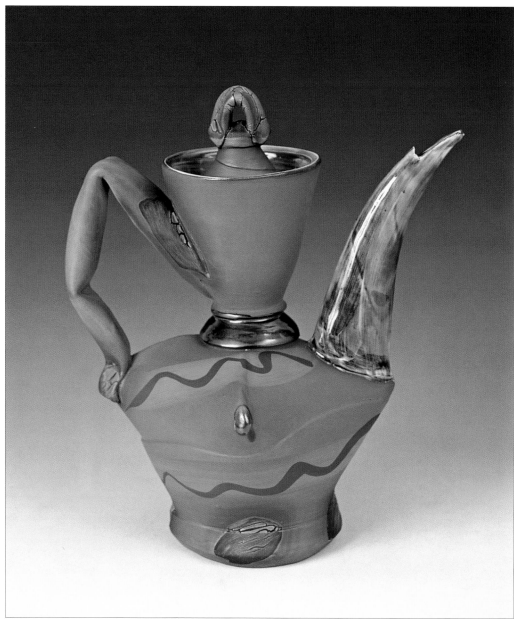

ARTIST: Woody Hughes
TITLE: Darted Teapot
DESCRIPTION: Wheel-thrown
terra-cotta and terra sigillata, 2000
DIMENSIONS: 10"H x 6"W x 6"D
COLLECTION: Private

Stanley Mace Andersen

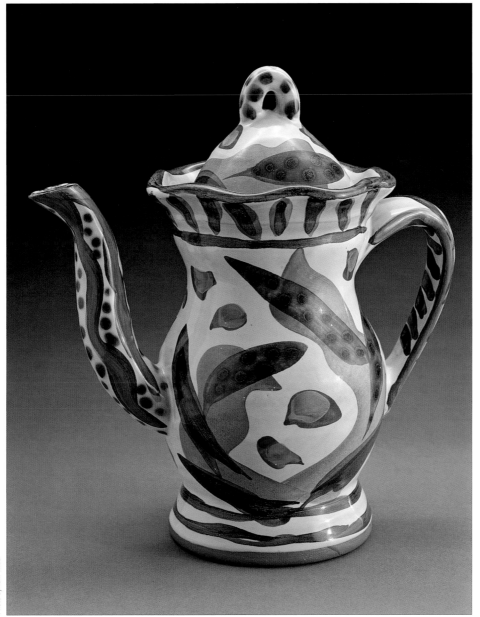

Photo by Tom Mills

ARTIST: Stanley Mace Andersen
TITLE: Teapot
DESCRIPTION: Earthenware with
majolica glaze, 2000
DIMENSIONS: 23"H x 11½"Dia
COLLECTION: Private

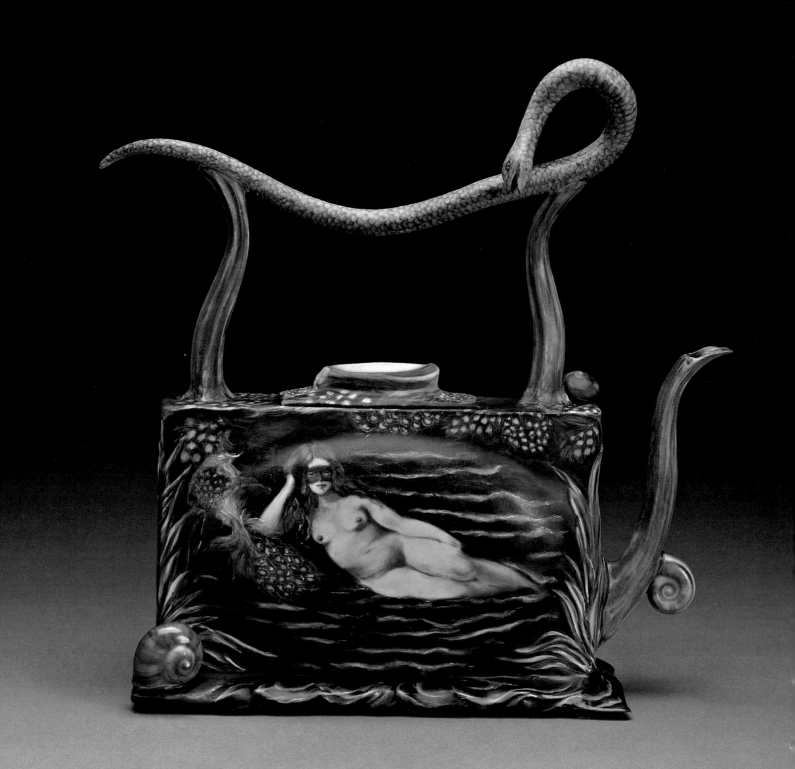

FIGURE AND NARRATIVE

As in the days of storied Athenian kraters, the ceramic vessel serves as a container of both goods and narratives. For many contemporary artists, the teapot is the vessel of choice as a medium for sharing autobiography, political and social commentary and commemoration. Others are attracted by the anthropomorphic quality of the teapot, which lends itself to becoming a figural character in an artist's story.

To several artists, the soft lines of the teapot suggest a female figure: Adrian Arleo in her mother and child pieces and Deborah Groover in her series of pieces based on feminine myths. Some see the teapot as a bust or head — a vehicle for a self-image or portrait; some see the teapot's handle, spout, body and lid as individual body parts — even phallic forms. Chuck Aydlett combines heads and figures in pieces that explore man's relationship with nature.

Red Weldon-Sandlin creates figurative sculptures in which the teapot is integral but not immediately obvious. In her piece *The Mystic Caravan of Dragon's Well*, a three-dimensional interpretation of an imaginary children's storybook, there are seven teapots; one is disguised as a turtle, one is a frog and five miniatures are painted with blue and white dragon patterns.

Joellyn Rock makes the teapot body a canvas for narrative about the self or the state of the world. In *Under a Watchful Eye*, the painted scene of a father observing a mother and child from above is ambiguous: is this a peaceful moment or foreboding family drama? Kathy King uses a comic book format, carving a series of words and images that contrast the male and female viewpoints in *Having It All — Career vs. Motherhood*.

Photo by Dennis Purdy, courtesy of Ferrin Gallery

Susan Thayer, *Ticklish Girl*, china-painted porcelain, 1999, 12"H x 11"W x 3"D, collection of Hila and Saul Rosen. "My work is the physical embodiment of a personal sensibility. Each piece I undertake begins as an opportunity to realize a vision, achieves a clarity through the development of the form, and continues to evolve in a series of related objects," says Susan Thayer.

"Because ceramic materials touch our lives daily, through a vast array of interaction, they have an intrinsic ability to provoke response. My work draws upon that familiarity, augmented by a vocabulary of images and forms derived from the history of porcelain vessels, to participate in the evolution of tradition as expressed through objects."

Leslie Rosdol

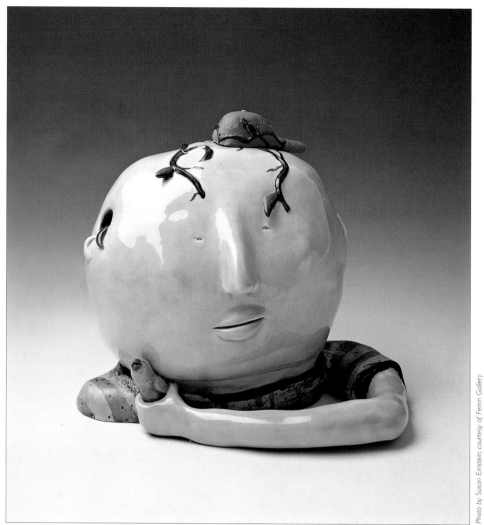

ARTIST: Leslie Rosdol
TITLE: Thief Teapot — The Art of Camouflage
DESCRIPTION: Porcelain, 1995
DIMENSIONS: 6"H x 6"W x 3"D
COLLECTION: David and Jacqueline Charak

"I work with the figure, and, for me, the drama is revealed in the small details like the bending of a hand, the waves in one's hair or even the pattern on a piece of clothing. Through the use of symbols and gestures, I try to capture the difficult, often humorous struggles we engage in when trying to carve out a niche for ourselves."

— Leslie Rosdol

Jack Earl

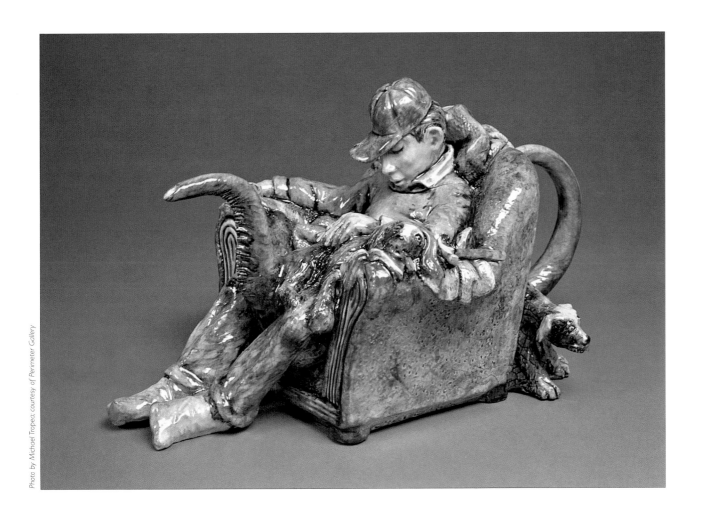

Photo by: Michael Tropea; courtesy of Perimeter Gallery

ARTIST: Jack Earl
TITLE: The Sleeping Boy in Sofa
DESCRIPTION: Porcelain, 1993
DIMENSIONS: 7 ½"H x 12"W x 7"D
COLLECTION: Myrna and Robert Zuckerman

Sergei Isupov

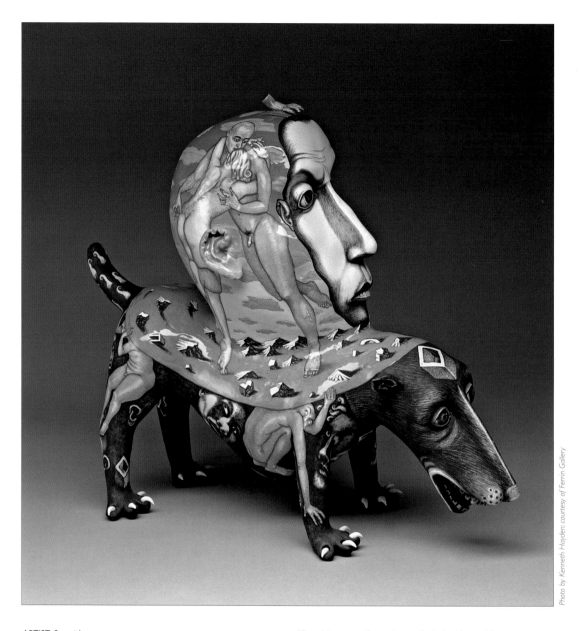

Photo by Kenneth Hayden; courtesy of Ferrin Gallery

ARTIST: Sergei Isupov
TITLE: Redemption Day
DESCRIPTION: Porcelain, 1998
DIMENSIONS: 13"H x 15"W x 6½"D
COLLECTION: Linda Sullivan

"Sergei Isupov confronts issues of relationships. . . . He presents us with power struggles and graphic psychosexual themes through an iconography filled with secrets that the viewer feels driven to decode."

— Judith S. Schwartz, Ph.D., *Confrontational Clay, The Artist as Social Critic*, Exhibits USA, Mid-America Arts Alliance, Kansas City, MO, 2000

Cindy Kolodziejski

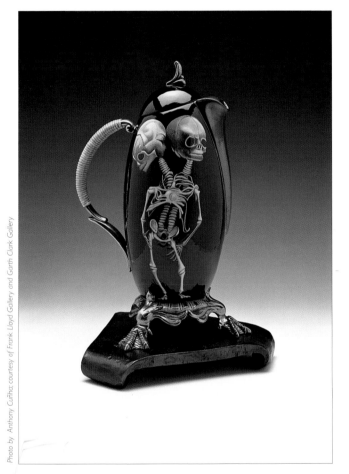

Photo by Anthony Cuñha; courtesy of Frank Lloyd Gallery and Garth Clark Gallery

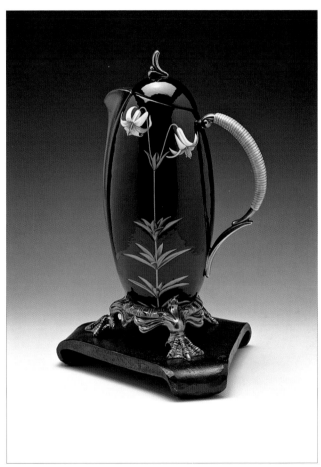

ARTIST: Cindy Kolodziejski
TITLE: Twins Teapot
DESCRIPTION: Earthenware, 1995
DIMENSIONS: 14"H x 7"W
COLLECTION: Charlotte Chamberlain Collection

"Good narrative art, like that of Cindy Kolodziejski, is analogous to good literature.
Beneath the skilled structure and masterful imagery lies the real work."

— Stephen Luecking, *Cindy Kolodziejski*, Garth Clark Gallery, New York, 1999

Deborah Kate Groover

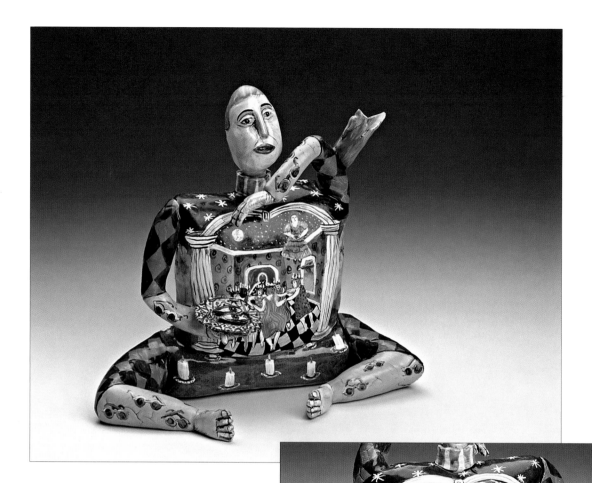

Photos by Howard Goodman; courtesy of Ferrin Gallery

ARTIST: Deborah Kate Groover
TITLE: Lucy: Summer Light
DESCRIPTION: Earthenware, 1999
DIMENSIONS: 10"H x 11"W x 6½"D
COLLECTION: Kenneth and Patricia Ferrin

Patti Warashina

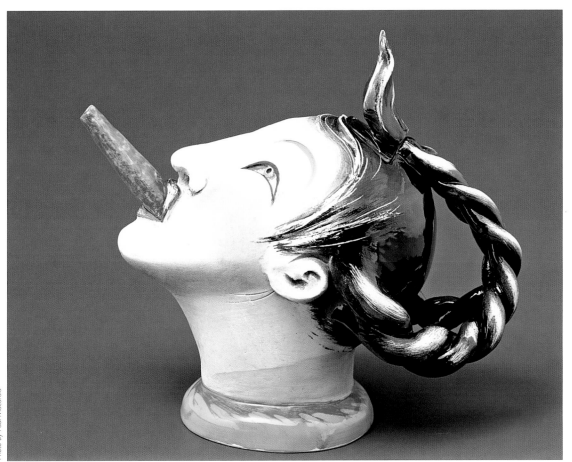

Photo by Paul Macardia

ARTIST: Patti Warashina
TITLE: Naughty Tongue
DESCRIPTION: Porcelain, edition of six, 1993
DIMENSIONS: 8"H x 12"W x 5"D
COLLECTION: Sonny and Gloria Kamm

Tom Rippon

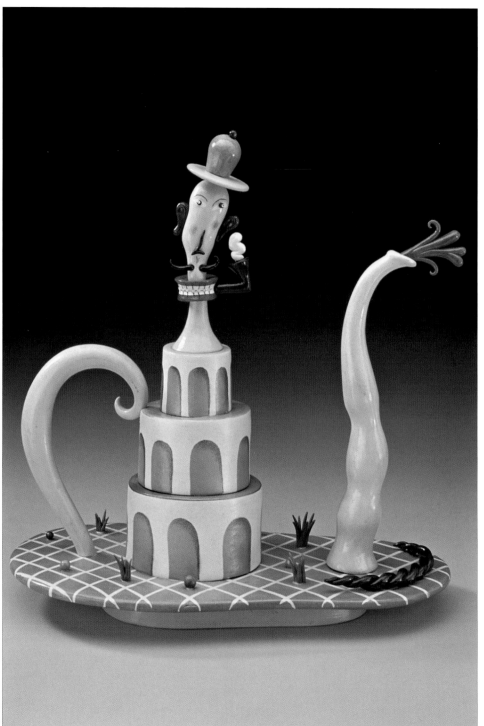

ARTIST: Tom Rippon
TITLE: Self-Portrait as an Italian
Architect
DESCRIPTION: Porcelain, lusters,
acrylic and pencil, 1998
DIMENSIONS: 14"H x 7½"W x 14"D

Akio Takamori

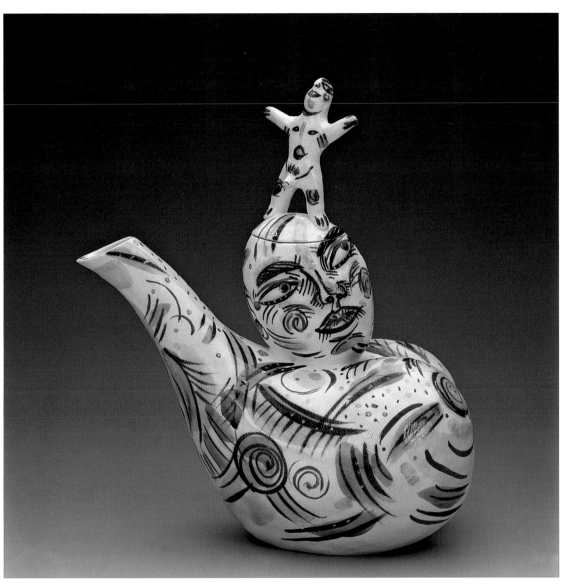

ARTIST: Akio Takamori

TITLE: Teapot

DESCRIPTION: Slip-cast porcelain, 1989

DIMENSIONS: 8"H x 7½"W x 4½"D

COLLECTION: The Donna Moog Teapot Collection, Charles A. Wustum Museum of Fine Arts, Racine, WI

"Akio Takamori's *Teapot* is a modern counterpoint to the scenes of romance and courtly love depicted on some historic teapots. The vessel is the head and bosom of a woman, the lid topped with a small male figure. While the woman's head is superseded by the male, he does not lead, for he is too small for that role. He is literally 'on her mind.' Her knowing sideways glance implies she is mindful of him and how to manage the interactions between the sexes."

— Bruce W. Pepich, Director, Charles A. Wustum Museum of Fine Art

Joellyn Rock

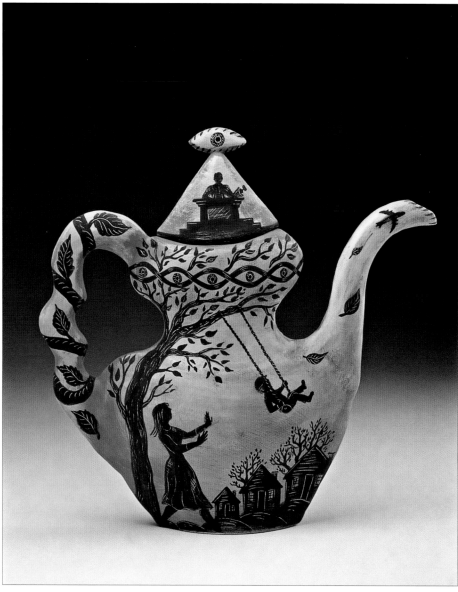

Photo by John Polak, courtesy of Ferrin Gallery

ARTIST: Joellyn Rock
TITLE: Under a Watchful Eye
DESCRIPTION: Underglaze on earthenware, 1998
DIMENSIONS: 14"H x 13"W x 4"D
COLLECTION: Kenneth and Patricia Ferrin

"Whether it is the cup that holds nourishment, the vase for flowers, the trophy as accolade or the funereal urn, the ceramic vessel — as image — resonates with meaning. When we look at ancient ceramic vessels, we are forced to remember what we have in common with people throughout time — our need to store nourishment, our need to bow to the forces of life and death, and our own bodily experience as vessel containing soul."

— Joellyn Rock

Adrian Arleo

Photo by Chris Autio

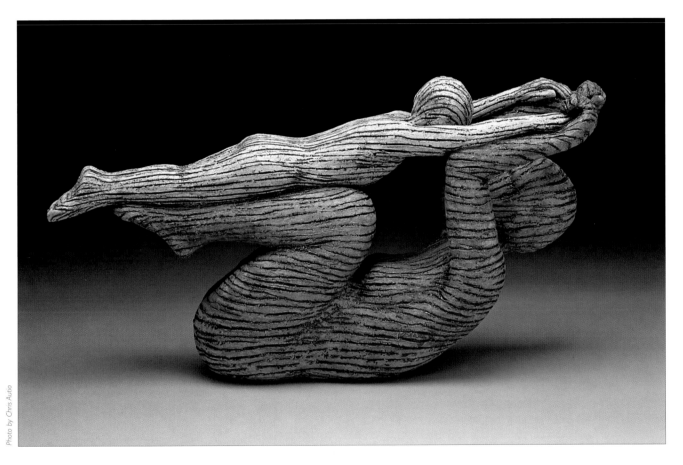

ARTIST: Adrian Arleo
TITLE: Woman and Child with Horizontal Stripes
DESCRIPTION: Clay, glaze, 1995
DIMENSIONS: 8"H x 16"W x 6"D
COLLECTION: Portland Community College

"I enjoy using the human form to anthropomorphize the three
necessary elements of spout, handle and lid, making the work
more mysterious and engaging by creating relationships
between figures — male with female, female with children,
female with female and figures alone in unusual positions."

— Adrian Arleo

Kurt Weiser

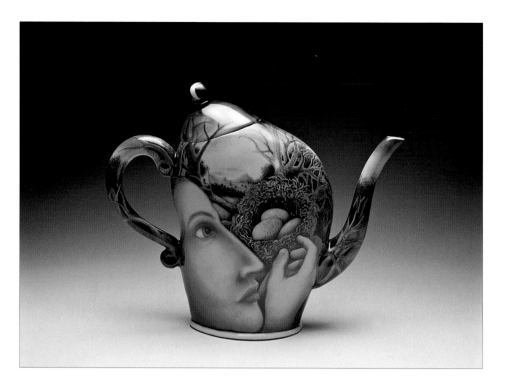

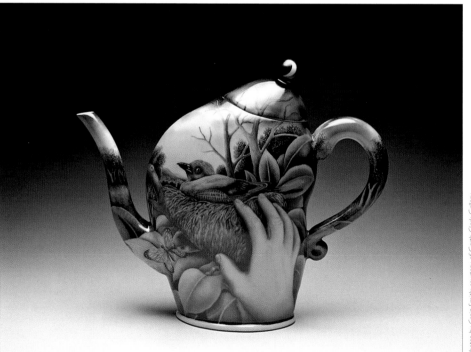

ARTIST: Kurt Weiser
TITLE: Naturalist
DESCRIPTION: Porcelain, 1996
DIMENSIONS: 10"H x 9"W x 5"D
COLLECTION: Private

Photos by Craig Smith; courtesy of Garth Clark Gallery

Leslie Lee

Photos by Elizabeth Ellington

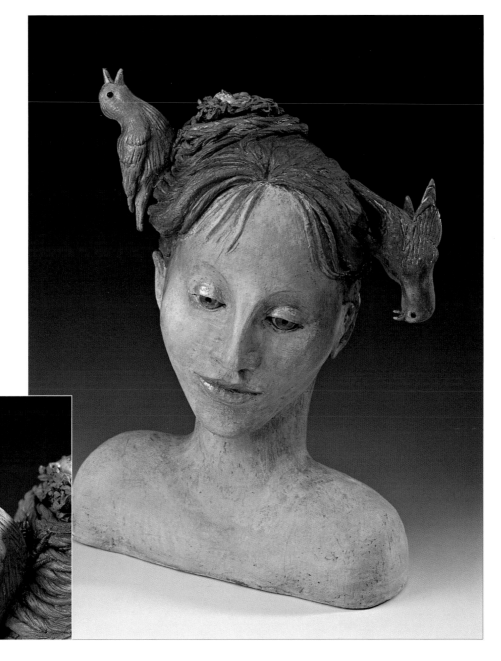

ARTIST: Leslie Lee
TITLE: Hatching News
DESCRIPTION: Clay, glaze, paint and wax, 1999
DIMENSIONS: 11"H x 8¼"W x 6"D
COLLECTION: Private

93

Michael Corney

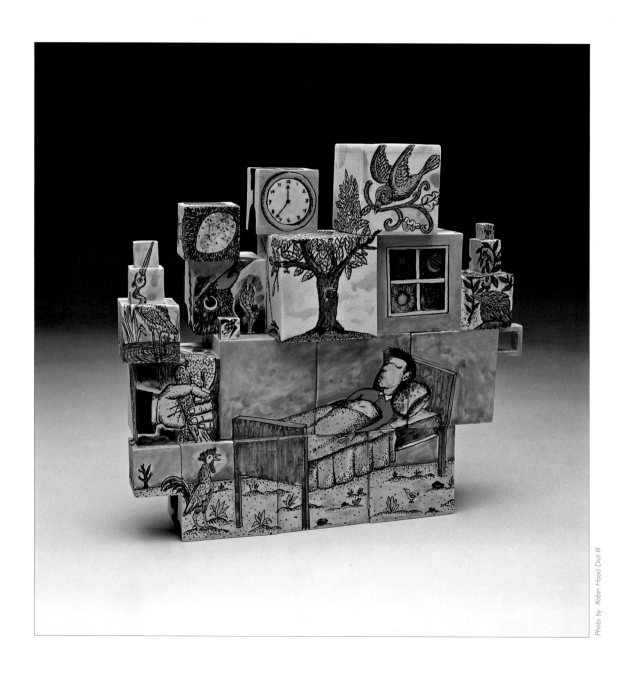

Photo by Robin Hood Dial III

ARTIST: Michael Corney
TITLE: Baby Bird #2
DESCRIPTION: Slip-cast porcelain, 1999
DIMENSIONS: 11"H x 10"W x 4"D

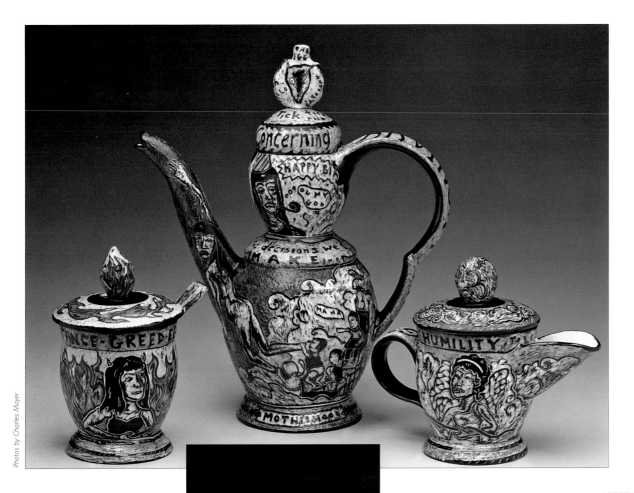

Photos by Charles Mayer

ARTIST: Kathy King
TITLE: Having It All — Career vs. Motherhood
DESCRIPTION: Mid-range porcelain with slips,
glaze and china paint, 1999
DIMENSIONS: Teapot: 13"H x 9"W x 6½"D, sugar bowl:
5½"H x 4"W x 4"D, creamer: 5½"H x 5"W x 4"D
COLLECTION: Susan Beech

"The inspiration for *Having It All — Career vs. Motherhood* came from
an ongoing conversation with girlfriends (all in our late 20s/early 30s)
about whether or when to plan a family and how it would conflict
with our pursuit of successful careers. We stopped and wondered if
men ever had similar conversations; thus, the text reads, 'Concerning
the decisions we make . . . what if the reverse were true?' and we see
a man pondering, 'Should I choose career or family?'"

— Kathy King

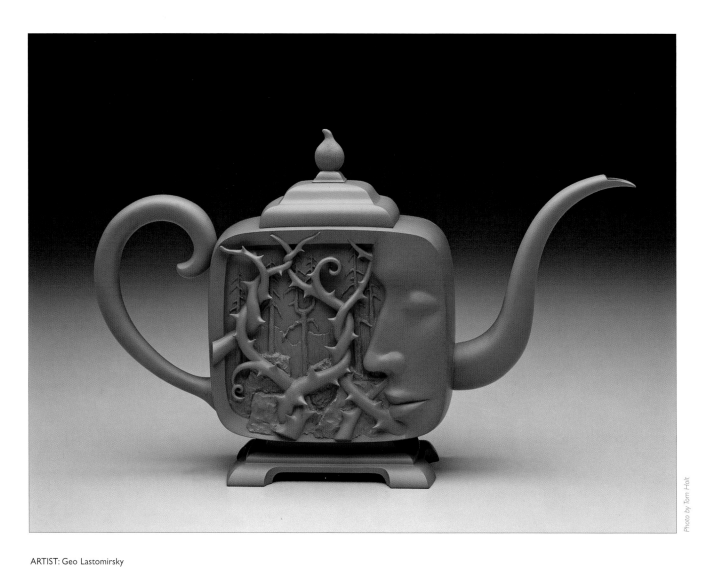

Photo by Tom Holt

ARTIST: Geo Lastomirsky
TITLE: Teapot #30
DESCRIPTION: Unglazed terra-cotta,
mixed media, 1995
DIMENSIONS: 7¼"H x 12"W x 2¼"D
COLLECTION: Private

Anne Kraus

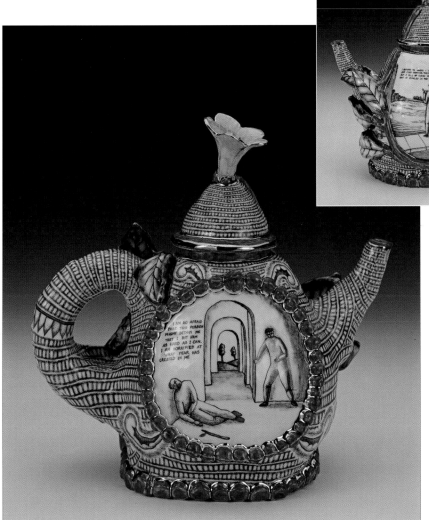

ARTIST: Anne Kraus
TITLE: Shining Leaf
DESCRIPTION: Wheel-thrown and hand-glazed
whiteware, 1989
DIMENSIONS: 9½"H x 9"W x 16½"D
COLLECTION: The Donna Moog Teapot
Collection, Charles A. Wustum Museum of Fine
Arts, Racine, WI

"Anne Kraus incorporates text in her works to
describe dreamlike situations that are simultane-
ously mundane and ominous. In *Shining Leaf*, she
deals with both the fear of strangers and the
attraction of home. While these concepts are not
necessarily associated with teapots, her inclusion
of narrative elements suggests the conversation
that often accompanies the consumption of tea
in social settings."

— Bruce W. Pepich, Director, Charles A. Wustum
Museum of Fine Arts

Mark Burns

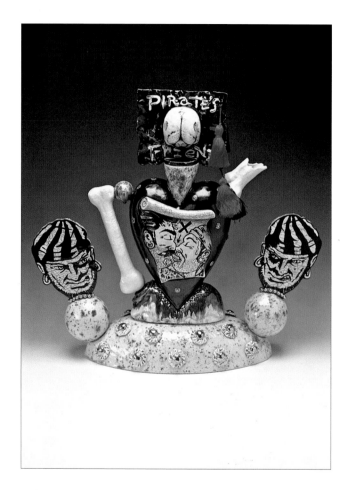 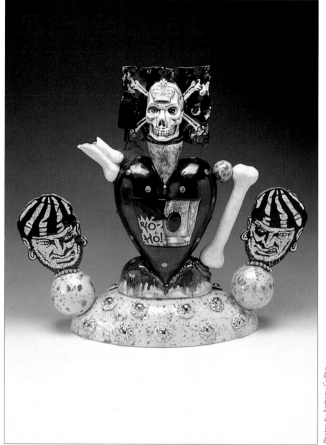

Photos by Anthony Cuñha

ARTIST: Mark Burns
TITLE: Jolly Rogers Redux
DESCRIPTION: Glazed earthenware, 1998
DIMENSIONS: 22"H x 23"W x 7"D
COLLECTION: Sonny and Gloria Kamm

"What makes Jolly Rogers jolly? Male bonding is the theme of this flamboyant drama in high-seas tea. From the black heart of tufted leather, upon which the treasure map of love unfurls, these pirates swap spit where *X* marks the spot. More an exercise in grand opera than a teapot, this vessel plainly tells what we all knew about pirates anyway."

— Mark Burns

Matt Nolen

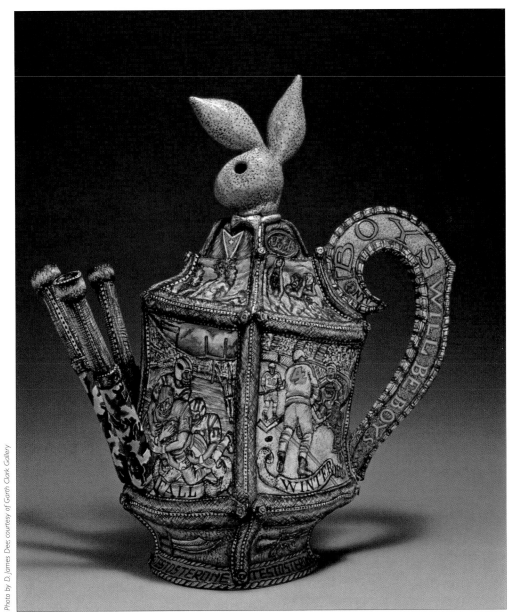

Photo by D. James Dee; courtesy of Garth Clark Gallery

ARTIST: Matt Nolen
TITLE: Testosterone Teapot
DESCRIPTION: Porcelain, 1994
DIMENSIONS: 25"H x 24"W
COLLECTION: Joan and Edward Green

Chuck Aydlett

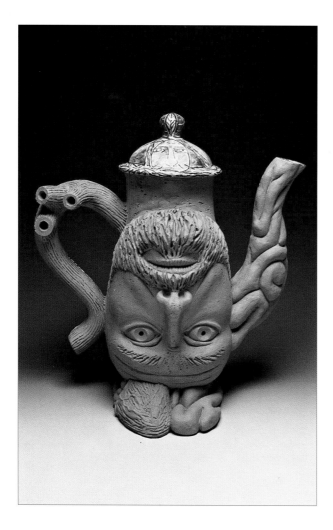 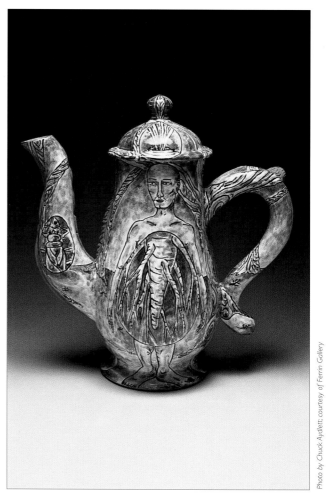

Photo by Chuck Aydlett; courtesy of Ferrin Gallery

ARTIST: Chuck Aydlett
TITLE: My Own Vessel
DESCRIPTION: Handbuilt earthenware with
majolica glaze and terra sigillata, 1998
DIMENSIONS: 14"H x 11"W x 7"D

Debra W. Fritts

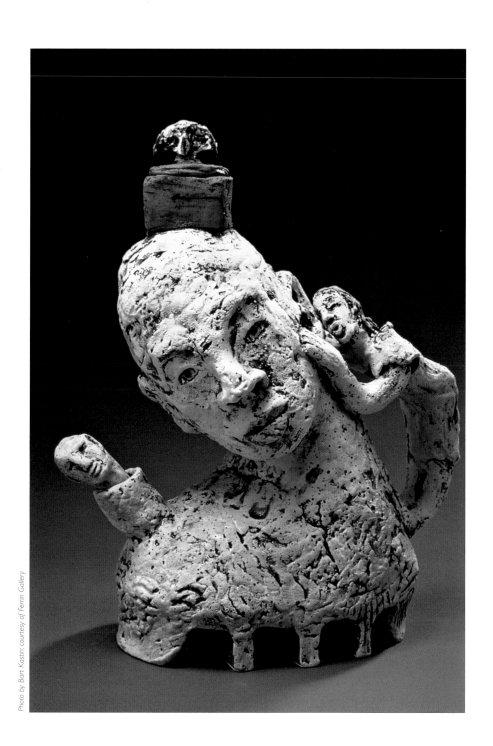

Photo by Burt Kastin; courtesy of Ferrin Gallery

ARTIST: Debra W. Fritts
TITLE: Secret Keeper
DESCRIPTION: Handbuilt, multifired
terra-cotta, 1998
DIMENSIONS: 12"H x 10"W x 5"D
COLLECTION: Joseph Blank

Kathryn McBride

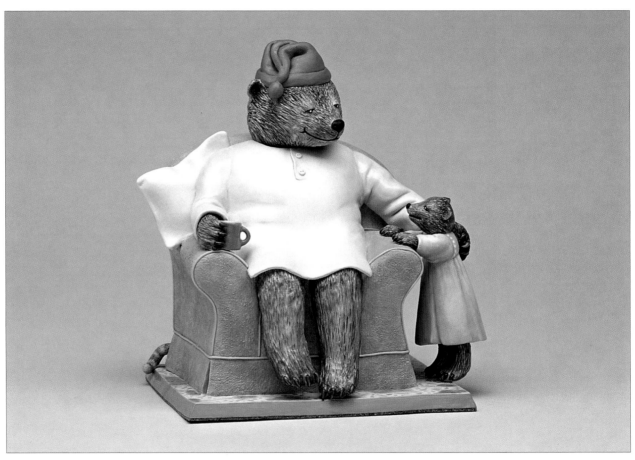

Photo by Sam Kleinman

ARTIST: Kathryn McBride
TITLE: Sleepytime — Bearly Awake
DESCRIPTION: Porcelain, 1996
DIMENSIONS: 9"H x 8"W x 6"D
COLLECTION: Celestial Seasonings

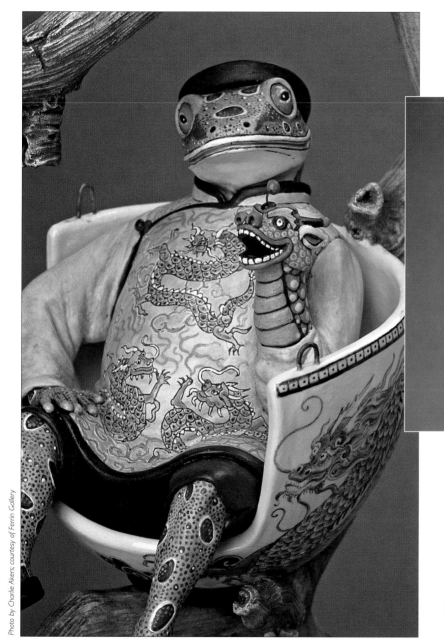

Photo by Charlie Akers; courtesy of Ferrin Gallery

ARTIST: Red Weldon-Sandlin
TITLE: The Mystic Caravan of Dragon's Well
DESCRIPTION: Ceramic, glaze, wood and acrylic paint, 2000
DIMENSIONS: 23"H x 10⅞"W x 9½"D

"This piece is based on a made-up story about a famous green tea in China (Lung Ching, named for the village, meaning the Dragon's Well). The teapot is comprised of two larger teapots (turtle and frog) and five miniature teapots.

"I use the subject of children's literature and the teapot form because it is something we all have a shared familiar experience with. My object is to evoke the viewer's memories of those stories — an invitation back to the age of wonder."

— Red Weldon-Sandlin

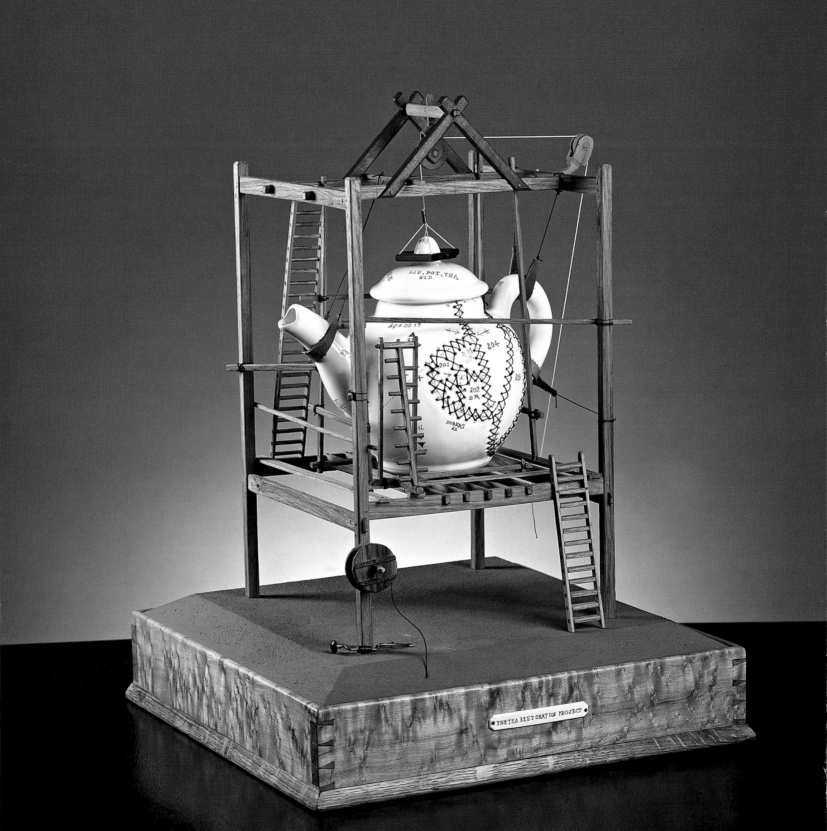

THE TEAPOT AS SUBJECT

Photo by Howard Goodman; courtesy of Ferrin Gallery

The teapots in this chapter represent work by artists using various media who have made the teapot the subject of their artwork. This conceptualization of the teapot form is redefined by each individual artist. For some who approach the teapot in the context of a larger body of work, the teapot image may be only a passing subject. For others, the teapot may be a recurring image, used as a departure point for a series of pieces addressing a variety of themes.

In the 1960s, two artists helped to transform the teapot from a functional to a conceptual object. With his energetic use of clay and subsequent revolutionary rejection of function, Peter Voulkos gave a whole generation of artists license to explore the vessel as a sculptural object. Robert Arneson took another route when he presented the everyday object as the subject of his sculptural vessels. In this chapter, several artists explore the complete transformation of the teapot by using a deconstructed teapot in a narrative with the teapot as a major character. Roy Superior comments on the human need to repair the irreparable in his piece *Restoration*, a small-scale fantasy world where the remains of a smashed teapot are surrounded by miniature scaffolding and tools for stitching the numbered fragments back together. Raymon Elozua reunites the shards of an exploded teapot by combining a steel skeleton with an internal spatial cavity.

Artists who are themselves collectors like to present their work in groupings. These fabricated settings permit the artists to control the context in which their teapots are viewed. In his collection boxes, Richard Marquis organizes found objects and his own multiple glass teapots in dioramas, while Paul Dresang's teapot emerges powerfully from a trompe l'oeil leather bag.

Roy Superior, *The Tea Restoration Project*, wood, ceramics and string, 1993, 19"H x 15"W x 15"D, collection of Pat and Alex Gabay. This is one of a series of monuments to futility that confronts the irony of contemporary life.

Raymon Elozua

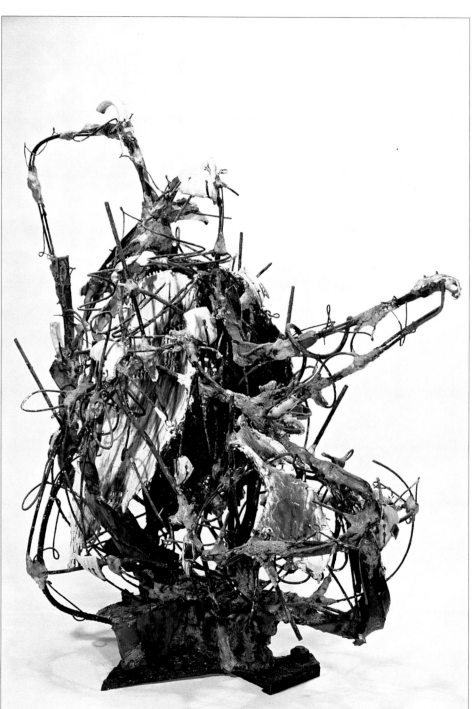

ARTIST: Raymon Elozua
TITLE: Wire Frame Teapot #2
DESCRIPTION: Terra-cotta and
commercial china with steel, 1994
DIMENSIONS: 35"H x 23"W x 41"D

Photo by Raymon Elozua

Thomas Mann

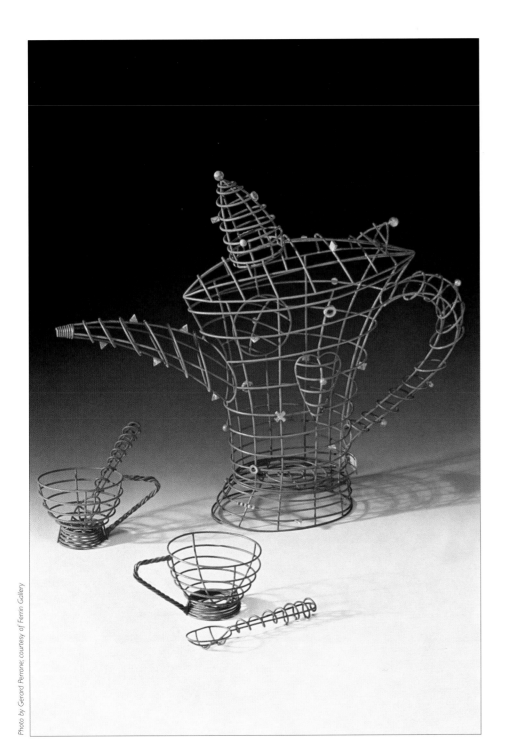

Photo by Gerard Perrone; courtesy of Ferrin Gallery

ARTIST: Thomas Mann
TITLE: Sleepytime Dream Teapot
DESCRIPTION: Steel, bronze and brass, 1996
DIMENSIONS: 14"H x 8"W x 6"D
COLLECTION: Sonny and Gloria Kamm

"While I am known principally for my work
in the medium of jewelry, I think of myself
as a sculptor working in a variety of
mediums. Unconsciously I know that I
apply background in technical theater design
to everything I make."

— Thomas Mann

David Gignac

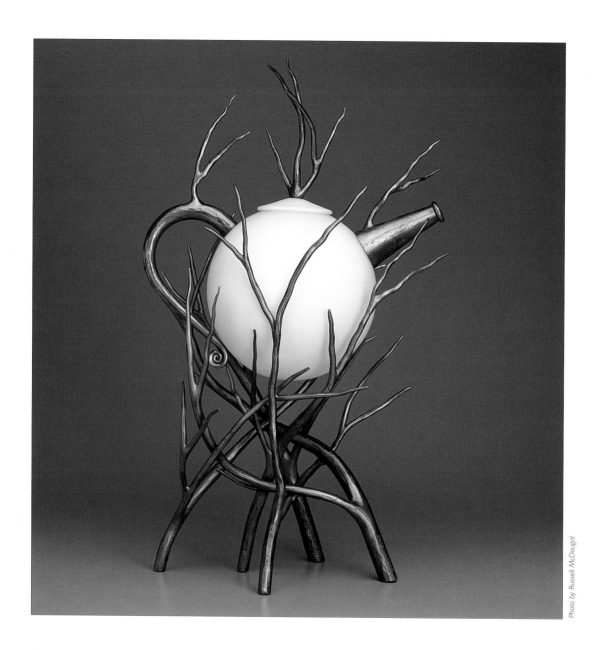

Photo by Russell McDougal

ARTIST: David Gignac
TITLE: Celestial Teapot
DESCRIPTION: Handblown glass and
forged steel, 1998
DIMENSIONS: 20"H x 13"W x 12"D
COLLECTION: Celestial Seasonings

Lucian Octavius Pompili

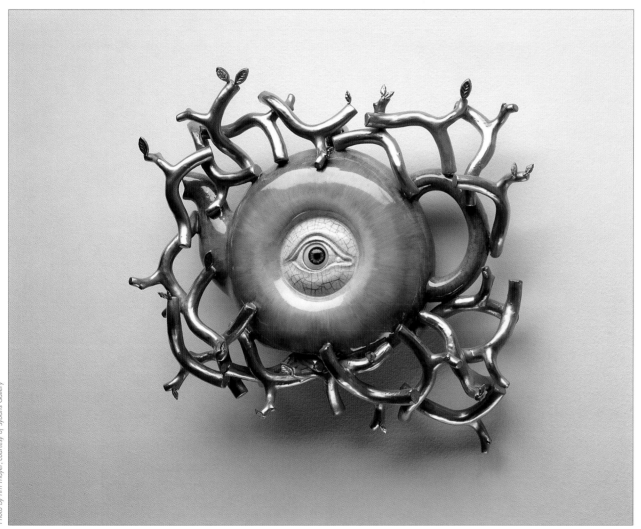

ARTIST: Lucian Octavius Pompili
TITLE: Rousseau's Cave
DESCRIPTION: Clay and glazes, 1999
DIMENSIONS: 10"H x 12"W x 4"D
COLLECTION: David and Jacqueline Charak

Kari Russell-Pool

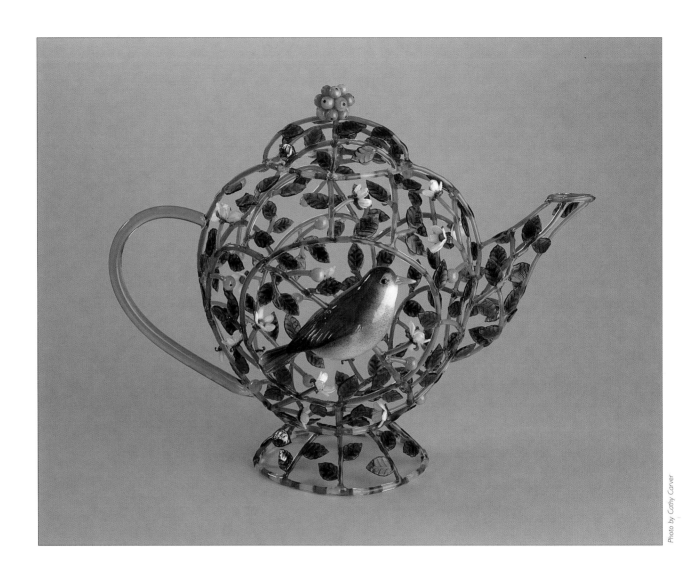

Photo by Cathy Carver

ARTIST: Kari Russell-Pool
TITLE: Robin with Orange Berries
DESCRIPTION: Blown and flame-worked glass, 1999
DIMENSIONS: 11"H x 16"W x 9"D
COLLECTION: Private

This piece was done in collaboration with Marc Petrovic.

Susan Thayer

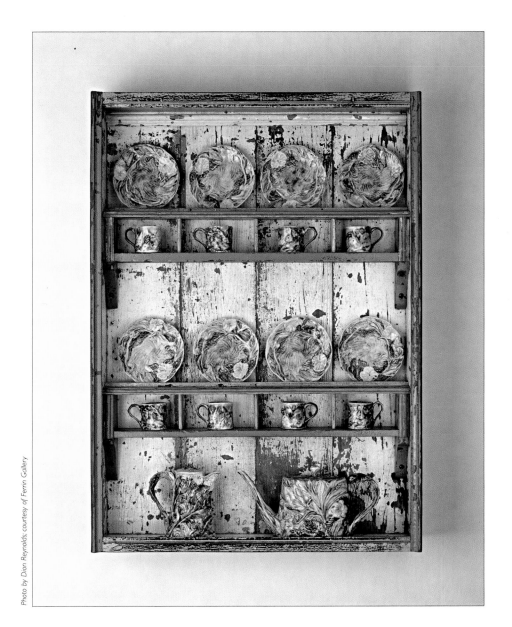

Photo by Dion Reynolds; courtesy of Ferrin Gallery

ARTIST: Susan Thayer
TITLE: Kitchen Cupboard
DESCRIPTION: Porcelain and found objects, 1995
DIMENSIONS: 31"H x 22"W x 5"D
COLLECTION: Artist

"Because ceramic materials touch our lives daily, through a vast array of interaction, they have an intrinsic ability to provoke response. My work draws upon that familiarity, augmented by a vocabulary of images and forms derived from the history of porcelain vessels, to participate in the evolution of tradition as expressed through objects."

— Susan Thayer

Michael Cohen

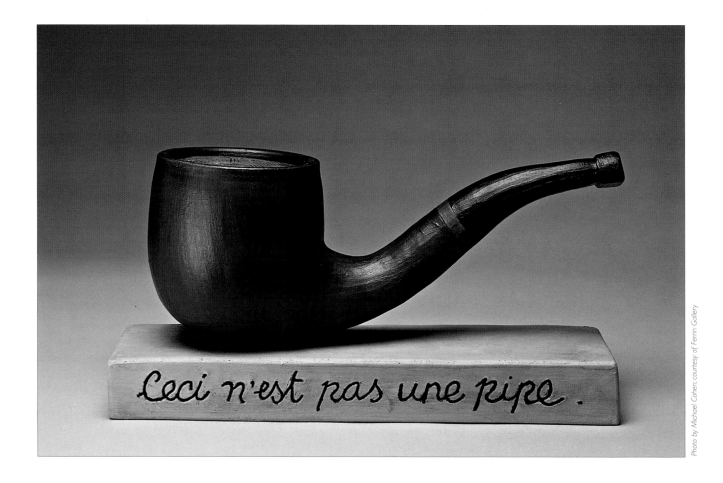

Photo by Michael Cohen; courtesy of Ferrin Gallery

ARTIST: Michael Cohen
TITLE: This Is Not a Teapot
DESCRIPTION: Stoneware, edition of six, 1995
DIMENSIONS: 8"H x 10"W x 3"D

Louis Marak

Photo by Louis Marak

ARTIST: Louis Marak
TITLE: Smoke Rings Teapot
DESCRIPTION: Low-fired glazed ceramic, 1999
DIMENSIONS: 14½"H x 19½"W x 4½"D
COLLECTION: Ed and Liliane Schneider

"I am intrigued by the unexpected juxtaposition
of dissociated images and incongruous objects.
Things inconsistent with common experience or
having contradictory qualities also fascinate me."

— Louis Marak

Donald Clark

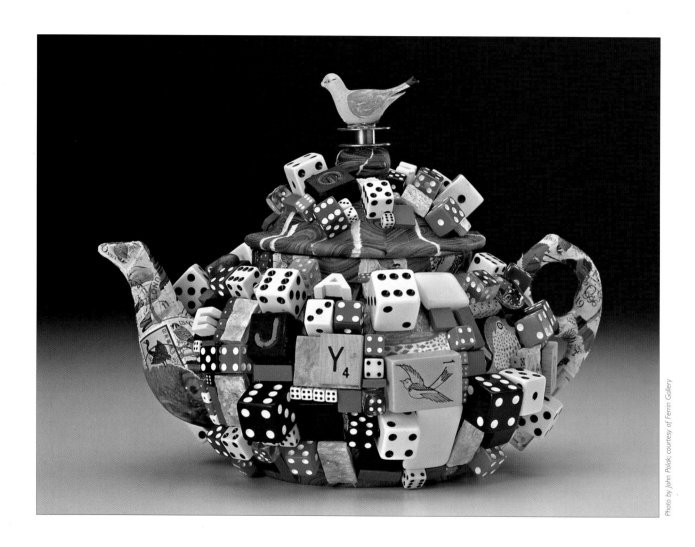

Photo by John Polak; courtesy of Ferrin Gallery

ARTIST: Donald Clark
TITLE: Bird Tea
DESCRIPTION: Found Objects, 1998
DIMENSIONS: 7"H x 9"W x 7½"D

Richard Milette

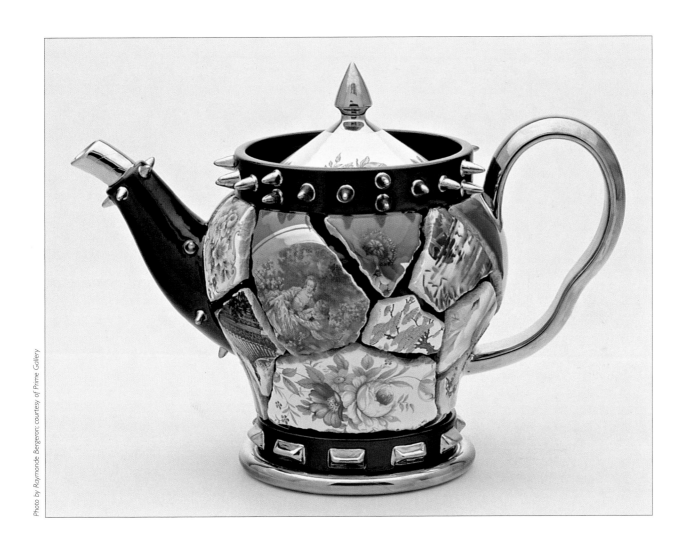

ARTIST: Richard Milette
TITLE: Teapot with Studded Collar
DESCRIPTION: Ceramic, 1995
DIMENSIONS: 8"H x 10½"W x 6"D
COLLECTION: Artist

Laszlo Fekete

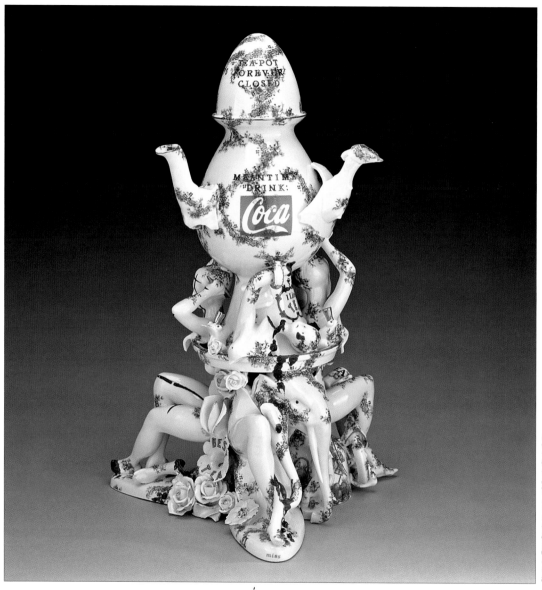

Photo by Tony Deck, courtesy of Garth Clark Gallery

ARTIST: Laszlo Fekete
TITLE: Teapot Forever Closed
DESCRIPTION: Porcelain, 1999
DIMENSIONS: 16½"H x 10¼"W x 10¼"D
COLLECTION: David and Jacqueline Charak

"I work with already once-fired detail pieces. I compose them with the help of real glue. With a second firing, I fix them together with the help of low-temperature clay that melts at the higher temperature."

— Laszlo Fekete

Ron Nagle

Photo by Don Tuttle; courtesy of Garth Clark Gallery

ARTIST: Ron Nagle
TITLE: Teapot #2
DESCRIPTION: Porcelain and overglaze, 1999
DIMENSIONS: 4¼"H x 6"W x 4½"D
COLLECTION: David and Jacqueline Charak

Paul A. Dresang

ARTIST: Paul A. Dresang
TITLE: Untitled
DESCRIPTION: Porcelain, 1999
DIMENSIONS: 12"H x 15"W x 8"D
COLLECTION: David and Jacqueline
Charak

"Surrounding the teapot with a case or
a bag has given me the opportunity to
exploit various levels of contrast and
sensuousness in the porcelain material.
With an expanded array of details, levels
of illusion and suggestion, I enjoy the
implications of opening and emergence,
containment and ceremony."

— Paul A. Dresang

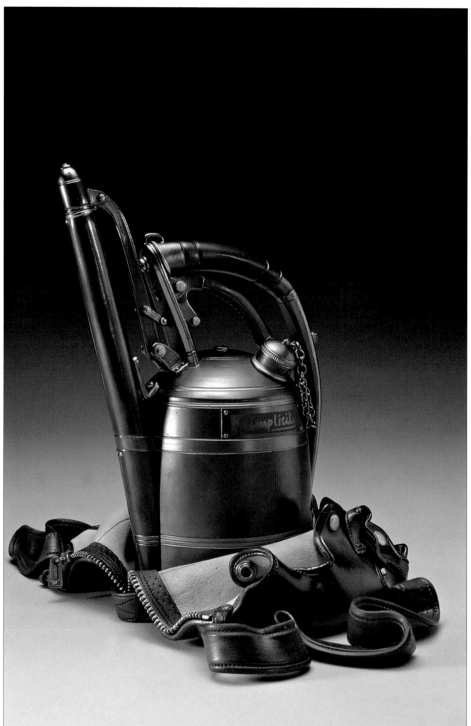

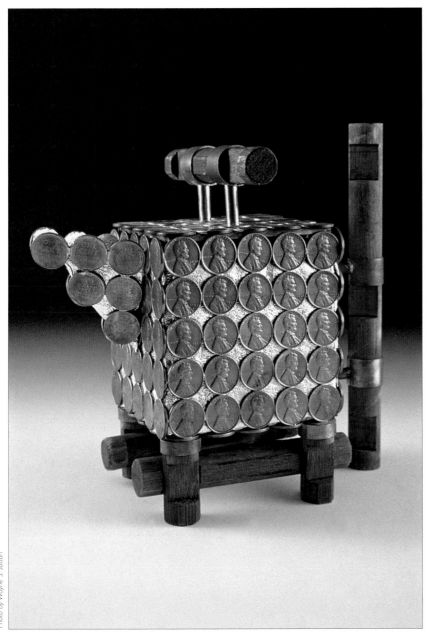

Photo by Wayne S. Sutton

ARTIST: Wayne S. Sutton
TITLE: $1.62
DESCRIPTION: Pennies and Lincoln Logs, 1996
DIMENSIONS: 8"H x 7"W x 6"D

Dennis Meiners

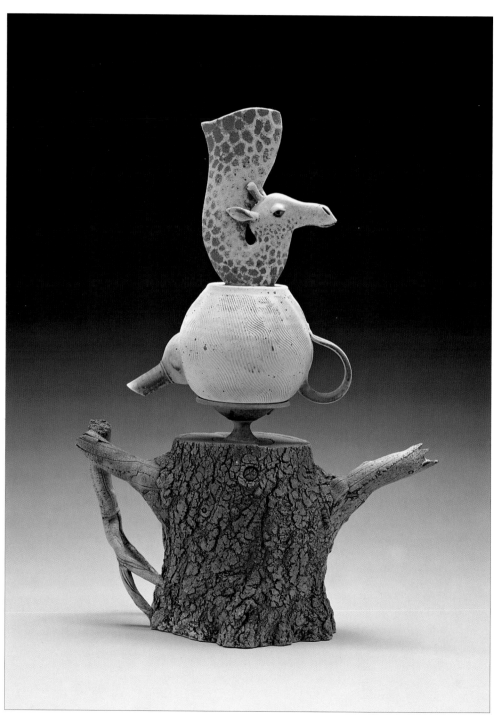

ARTIST: Dennis Meiners
TITLE: Giraffe Double Teapot
DESCRIPTION: Slab-built and
thrown stoneware, 1995
DIMENSIONS: 20"H x 13"W
COLLECTION: Private

Photo by Bill Bachhuber

Joan Takayama-Ogawa

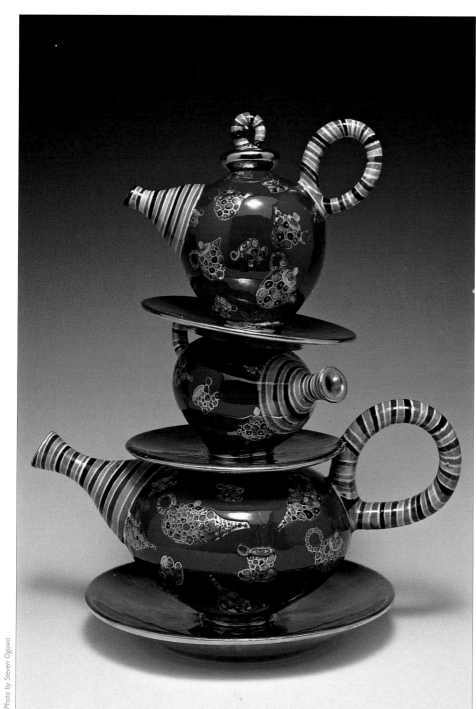

Photo by Steven Ogawa

ARTIST: Joan Takayama-Ogawa
TITLE: Tea Tower
DESCRIPTION: Ceramic with china paints,
1999
DIMENSIONS: 26"H x 20"W x 20"D
COLLECTION: Los Angeles County
Museum of Art

"By stacking simple, ordinary and
recognizable teapots, cups and saucers,
the fragile nature of clay is explored and
function is addressed. While [the parts of
Tea Tower] may look like they can be
unstacked, washed and used, they are
one connected, nonfunctional mass.
Because fired clay does not disintegrate,
[Tea Tower is] intended to celebrate ceramic
monuments and their quest for eternity."

— Joan Takayama-Ogawa

Richard Marquis

ARTIST: Richard Marquis
TITLE: Object Comparison Box #1-94
DESCRIPTION: Blown Zanfirico glass,
mirror, Vitrolite, sheet glass, found objects,
paint and silicone, 1993–1994
DIMENSIONS: 22"H x 11¾"W x 3½"D
COLLECTION: Johanna Nitzke Marquis

Carol Cohen

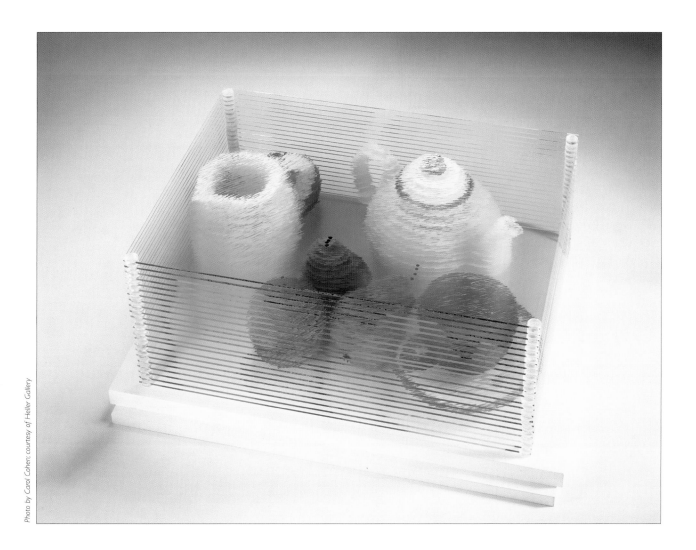

Photo by Carol Cohen; courtesy of Heller Gallery

ARTIST: Carol Cohen
TITLE: Tea and Fruit
DESCRIPTION: Painted and stacked glass, 1987
DIMENSIONS: 9"H x 16"W x 10"D
COLLECTION: Jerome and Mimi Frankel

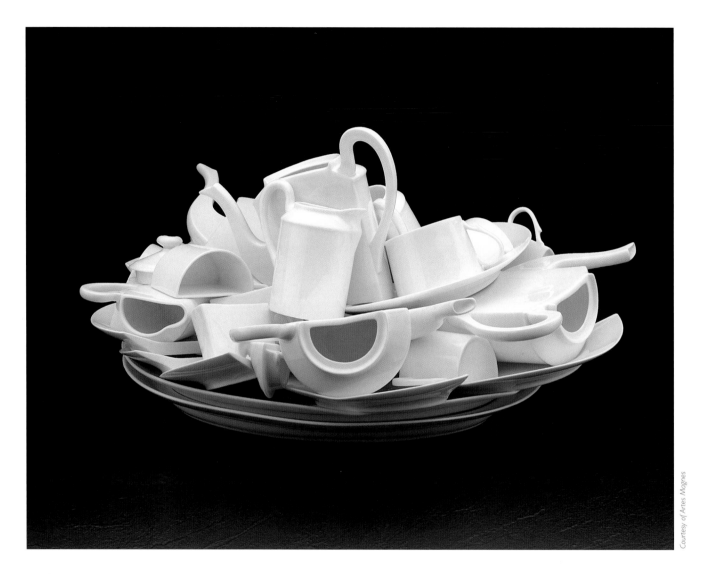

Courtesy of Artes Magnes

ARTIST: Arman

TITLE: As in the Sink (II), Edition of 50

DESCRIPTION: Porcelain, 1990

DIMENSIONS: 11"H x 16"W x 22"D

This limited-edition centerpiece was manufactured
in Limoges, France, by porcelain manufacturer
Bernardaud. Using the cups, saucers, plates and
teapots from his series *Demi Tasse*, Arman achieves a
sculptural accumulation giving the illusion of dishes
randomly placed. Each element of the centerpiece
becomes permanently fixed by means of a final glaze.

Irvin Tepper

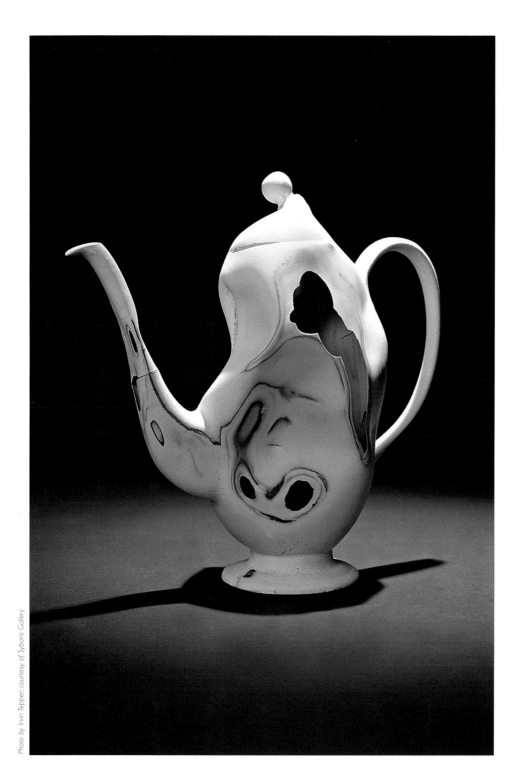

Photo by Irvin Tepper; courtesy of Sybaris Gallery

ARTIST: Irvin Tepper
TITLE: T-Boogie
DESCRIPTION: Porcelain, 1996
DIMENSIONS: 8"H x 7"W

"I make teapots not so much for the form and complexity of the shape, but for their social function in which their role is an absolute necessity. They bear witness to past faces, events and conversations.

"My teapots are fragile — made from porcelain — and translucent. They leak, can't pour, don't work, because they are metaphors in which they serve as a life's roadmap for what the teapot has experienced, frozen in time, reminding the viewer that what matters is not the days we live but how we live its moments."

— Irvin Tepper

CONTRIBUTING GALLERIES

The following galleries have generously contributed to this book. Each gallery listed exhibits work by one or more artists featured in the book; all are exceptional resources both for works of art and for information about the artists they represent.

Allan Stone Gallery
New York

Blue Heron Gallery
Maine

Blue Spiral 1
North Carolina

Braunstein/Quay Gallery
California

del Mano Gallery
California

Elliott Brown Gallery
Washington

Ferrin Gallery
New York

Frank Lloyd Gallery
California

Franklin Parrasch Gallery
New York

Garth Clark Gallery
New York

George Adams Gallery
New York

Helen Drutt Gallery
Pennsylvania

Heller Gallery
New York

John Elder Gallery
New York

John Natsoulas Gallery
California

Mobilia Gallery
Massachusetts

Nancy Margolis Gallery
New York

Perimeter Gallery
Illinois

PINCH
Massachusetts

Prime Gallery
CANADA

Rena Bransten Gallery
California

Snyderman Gallery/The
Works
Pennsylvania

Sybaris Gallery
Michigan

Trax Gallery
California

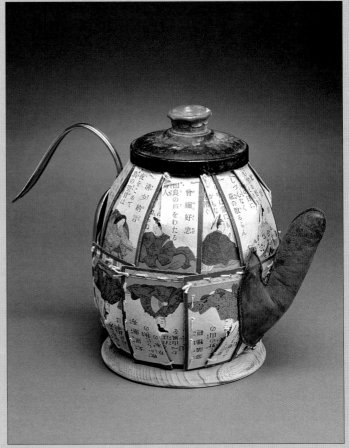

Photo by Harper Fritsch Studios

ARTIST: Bird Ross
TITLE: Dozo
DESCRIPTION: Japanese cards, thread, glove, wood plate, spoon, button and paint can lid, 2000
DIMENSIONS: 7"H x 10"W x 5"D
COLLECTION: Artist

CONTRIBUTING ARTISTS

Elaine Alt
Page 128

Stanley Mace Andersen
Page 79

Daniel Anderson
Page 35

Kate Anderson
Page 55

Adrian Arleo
Page 91

Arman
Page 124

Robert Arneson
Page 16

Rudy Autio
Page 14

Chuck Aydlett
Page 100

Ralph Bacerra
Page 68

Clayton Bailey
Page 15

D. Hayne Bayless
Page 128

Bennett Bean
Page 71

Susan Beiner
Page 56

James E. Binnion
Page 69

Susan Bostwick
Page 42

Michael Boyd
Page 76

Mark Burns
Page 98

Donald Clark
Page 114

Bruce Cochrane
Page 52

Carol Cohen
Page 123

Michael Cohen
Page 112

Annette Corcoran
Page 39

Michael Corney
Page 94

David Damkoehler
Page 75

Marilyn da Silva
Pages 2–3, 33

Harris Deller
Page 64

Paul A. Dresang
Page 118

Jack Earl
Page 83

Raymon Elozua
Page 106

Susan R. Ewing
Page 74

Laszlo Fekete
Page 116

Léopold L. Foulem
Page 46

Viola Frey
Page 10

Debra W. Fritts
Page 101

David Furman
Page 41

David Gignac
Page 108

Deborah Kate Groover
Page 86

Chris Gustin
Page 70

Dorothy Hafner
Page 72

Mark Hewitt
Page 21

Steven Hill
Page 27

Albert Hodge
Page 23

Kelly Torché Hong
Page 48

Coille McLaughlin Hooven
Page 11

Patrick Horsley
Page 62

Woody Hughes
Page 78

Sergei Isupov
Page 84

Jan McKeachie Johnston
Page 28

Randy J. Johnston
Page 26

Karen Karnes
Page 17

Beth Katleman
Page 57

Miriam Kaye
Page 54

Kathy King
Page 95

Karen Koblitz
Page 44

Cindy Kolodziejski
Page 85

Robin Kraft
Page 4

Anne Kraus
Page 97

Michael Lambert
Page 73

Geo Lastomirsky
Pages 30, 96

Leslie Lee
Page 93

Ah Leon
Page 32

Randy Long
Page 63

Michael Lucero
Page 59

David Mackenzie
Page 15

Warren MacKenzie
Page 13

Thomas Mann
Page 107

Louis Marak
Page 113

Richard Marquis
Pages 11, 122

Kathryn McBride
Page 102

Dennis Meiners
Page 120

Richard Milette
Page 115

Ron Nagle
Page 117

Matt Nolen
Page 99

Richard Notkin
Page 34

Kevin J. O'Dwyer
Page 60

Jeff Oestreich
Page 25

George Ohr
Page 12

Ben Owen III
Page 12

Eunjung Park
Page 37

Greg Payce
Page 49

Lucian Octavius Pompili
Page 109

Tom Rippon
Page 88

Joellyn Rock
Page 90

Mary Roehm
Page 53

Leslie Rosdol
Page 82

Bird Ross
Page 126

Kari Russell-Pool
Page 110

Adrian Saxe
Page 50

Scott Schoenherr
Page 58

Nancy Selvin
Page 6

Ellen Shankin
Page 20

Mark Shapiro
Page 18

Kathryn Sharbaugh
Page 65

Richard Shaw
Page 15

Cindy Sherman
Page 47

Michael Sherrill
Front cover, page 66

Peter Shire
Page 67

Linda Sikora
Page 22

Michael Simon
Page 29

Farraday Newsome Sredl
Page 36

Mara Superior
Pages 1, 51

Roy Superior
Page 104

Wayne S. Sutton
Page 119

Richard Swanson
Page 38

Akio Takamori
Page 89

Joan Takayama-Ogawa
Pages 40, 121

Claudia Tarantino
Page 43

Irvin Tepper
Page 125

Susan Thayer
Pages 80, 111

Eric Van Eimeren
Page 77

Peter Voulkos
Page 17

Barbara Walch
Page 24

Patti Warashina
Page 87

Kurt Weiser
Page 92

Red Weldon-Sandlin
Page 103

Beatrice Wood
Page 8

RECOMMENDED READING

American Ceramics
1876 to the Present
Garth Clark
Abbeville Press, 1986

The Book of Cups
Garth Clark
Abbeville Press, 1990

Collectible Teapots
A Reference and Price Guide
Tina M. Carter
Antique Trader, 2000

The Cube Teapot
Anne Anderson
Richard Dennis, 2000

The Eccentric Teapot
Four Hundred Years of Invention
Garth Clark
Abbeville Press, 1989

**The History of American
Ceramics**
1607 to the Present
Elaine Levin
Harry N. Abrams, 1988

Novelty Teapots
Five Hundred Years of Art and Design
Edward Bramah
Quiller Press, 1992

Teapot Mania
*The Story of the British Craft Teapot
and Teacosy*
Chloë Archer
Norfolk Museums Service,
Breckland Print, Limited, 1995

**Teapot Treasury and Related
Items**
Richard Luckin
RK Publishing, 1987

Teapots
*The Collector's Guide to Selecting,
Identifying and Displaying New and
Vintage Teapots*
Tina M. Carter
Courage Books, 1995

Tempest in a Teapot:
The Ceramic Art of Peter Shire
Hunter Drohojowska
Rizzoli, 1991

ARTIST: Elaine Alt
TITLE: The Queen
DESCRIPTION: Earthen-
ware, 1998
DIMENSIONS: 21"H x 10"W
x 7½
COLLECTION: Private

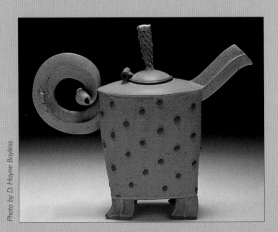

Photo by D. Hayne Bayless

ARTIST: D. Hayne Bayless
TITLE: Oval Teapot with
Hinged Lid
DESCRIPTION: Stoneware,
1999
DIMENSIONS: 12"H x 13"W
x 4"D
COLLECTION: Private

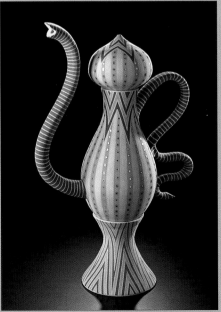

Photo by Tommy Olof Elder